Gaudí

Dalí

Antoni Salvador

Gaudí Dalí

Antoni Salvador

HDi

HARPER
DESIGN
international

Publisher: **Paco Asensio**

Editorial Coordination: **Llorenç Bonet**

Text: **Llorenç Bonet, Cristina Montes (pp. 14–28)**

Translation: **William Bain**

Art Director: **Mireia Casanovas Soley**

Graphic Design and Layout: **Emma Termes Parera**

Dalí's Works: © **Salvador Dalí, Gala-Salvador Dalí Foundation, VEGAP, Barcelona, 2002**
Photographs of Dalí and of his works: © **foto Descharnes/Daliphoto.com**

Photographs of Gaudí's Works: © **Pere Planells, except**
 © **Miquel Tres, pages 25, 27 (above), 43 (Bellesguard), 49**
 © **Roger Casas, pages 13 (detail of Casa Vicens), 15**
 © **Joana Furió, pages 30 (façade of Casa Milà, chimneys), 60**
 © **Brangulí. Arxiu Nacional de Catalunya, page 11**
 © **Museu Comarcal Salvador Vilaseca, Reus, page 6**
 © **AZ Disseny SL, pages 65, 67**
 © **BD ediciones de diseño SA, page 68. Dalí's furniture is**
 currently distributed.

Drawings in the fly leafs: © **Edgardo Minond**

Copyright © 2003 by HDI, an imprint of HarperCollins Publishers and LOFT
Publications

First published in 2003 by:
Harper Design International, an imprint of HarperCollins Publishers
10 East 53rd Street
New York, NY 10022

Distributed throughout the world by:
HarperCollins International
10 east 53rd Street
New York, NY 10022
Fax: (212) 207-7654

ISBN 0-06-053993-3
D.L.: B-37.878-02

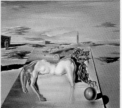

Editorial project:

LOFT Publications
Domènech, 9 2-2
08012 Barcelona. Spain
Tel.: +34 932 183 099
Fax: +34 932 370 060
e-mail: loft@loftpublications.com
www.loftpublications.com

Printed by: Gràfiques Anman, Sabadell. Spain

6 **Dalí and Gaudí: Of geniuses and monsters**

8 **Antoni Gaudí**

10 **Biography**

14 **Works**

32 **Antoni Gaudí-Salvador Dalí**

34 **Soft Forms and Hard Forms**

40 **Fragments and Transformations**

46 **Natural and Artificial**

52 **Empty Spaces**

58 **A Sensitive Reality**

64 **Furniture and Design**

70 **Salvador Dalí**

72 **Biography**

76 **Works**

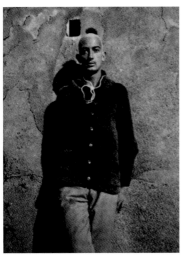
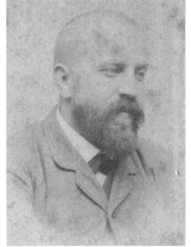

This photo of Dali with his head shaved, save for a lock of hair on top reminiscent of a pompon on a sailor´s hat, is an early statement made before he came into contact with the surrealists. This photo sheds light on the attitude and personality of the young painter from Ampurda, who would go on to revolutionize the surrealist group formed by André Breton.
In this photo, one of only two in existence due to his distaste for appearing in photographs, Gaudí is thirty-five years old and appears quite timid. Strangely enough, his head is shaved, unusual for both Gaudí and the period.

GAUDÍ AND DALÍ: OF GENIUSES AND MONSTERS

Antoni Gaudí i Cornet (1852–1926) and Salvador Dalí i Domènech (1904–1989) never met. They share neither an age nor an artistic movement; they lived no parallel life. One is remembered as a modest, timid man, a bachelor and highly religious; the other is remembered as an ego-maniacal eccentric, a painter of genius who always did as he pleased. Dalí was cosmopolitan, Gaudí hardly ever set foot outside Catalonia. Yet the work of these two Catalan artists shares a clear connection we need do no more than compare the work to locate the common link.

What is it, then, that joins them? A fragment of text called *The Vision of Gaudí* written by Dalí gives us some insight: "During our memorable meeting at the Roussy de Sales house, in 1929, Le Corbusier told me that Gaudí was the crying shame of the city of Barcelona. It was during this same meeting that, when he asked me if I had ideas about the future of art, I answered: 'Architecture will be soft and hairy' and then said categorically that the last great genius in architecture was Gaudí, whose name in Catalan means 'to enjoy oneself', just as Dalí means 'desire.' I explained to him that joy and desire are natural to Catholicism and the Mediterranean Gothic, reinvented and taken to climax by Gaudí. Toward the end of his life, Le Corbusier, by then thinking differently,

would finally consider Gaudí to be a monster of creativity.

Over the years, the once discredited work of Gaudí came to be recognized not only by Le Corbusier but by a great many people. And the same would happen with Dalí's work: the initial failure to understand would give rise to admiration under the name's of ingenious and monstrous, irrevocable epithets for their work.

This is the point of contact where we find both artists: genius. Here we have artists capable of breaking all of the rules, creating a new world without worrying about whether their fellows like it. In the twentieth century, Gaudí and Dalí are the two artists classified as genius without qualification. The other great creators of the century will also be remembered, but differently. Le Corbusier and Mies Van der Rohe make up part of the generation of the "heroes" of the Modernist movement, Picasso will be "le petit Goya," and Duchamp will simply be Duchamp. But in any text about Dalí and Gaudí, the word genius will appear on the very first page.

They are both geniuses who are the two sides of the same coin: different, but in the same universe. Their world is both soft and hard, super-real, fragmented, sublime, reaching the depths of nature and horribly beautiful.

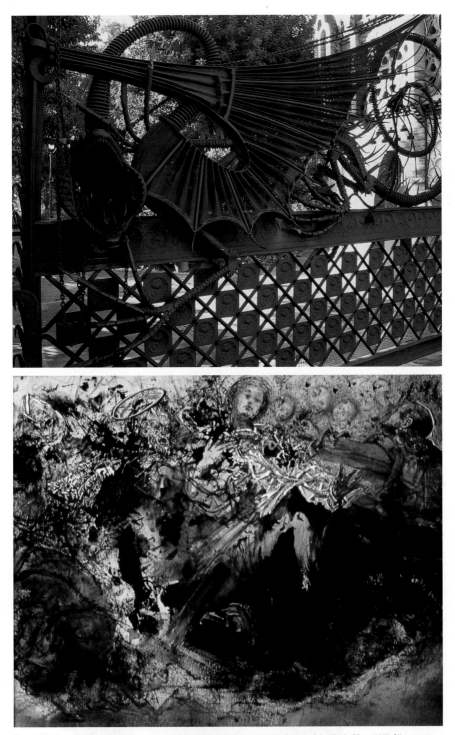

Door of the Finca Güell and **Saint Salvador and Antoni Gaudí Fighting Over the Crown of the Virgin Mary**, 1959. Oil on canvas

ANTONI GAUDÍ

Antoni Gaudí 1852–1926

Antoni Gaudí i Cornet was born in Reus to a family of humble boilermakers. As the youngest of five children, he was the only one to survive his parents; the other four children all died at a very young age. While still quite small Gaudí was diagnosed with arthritis, a condition that would remain with him all his life. He was, because of this affliction, a sickly child who had problems walking. Even so, he was able to attend the kindergarten of Francesc Berenguer, and later enrolled in the local school (Escuelas Pías) in Reus at the age of eleven. It was here that Gaudí showed great powers of observation, probably because his sense of vision was his only means of interacting with the world. He was a reserved child with a difficult character, and his grades were not good. But he excelled in drawing, which made it possible for him to collaborate in the school magazine. At an older age, he would recall his modest past, and he always remembered gratefully both the school and his father's trade, which aided him in his years as an architect in working with spaces.

At the age of 21, he entered an architecture school in Barcelona after a year of preparatory studies. Not standing out as a brilliant student, halfway through his school career he needed to work with a master builder to help the precarious family finances, which would also mean the sale of the property in Reus. Far from making his studies difficult, the work gave him a taste of the practical side of his profession. It also allowed him to meet architects who would recommend him to future clients once he completed his studies.

At the time when Gaudí studied, the books of the French architect Violet-le-Duc were much in fashion. Aside from being a prestigious proponent of the neo-Gothic, Violet-le-Duc was one of the first professionals to use concrete in the restoration of many medieval buildings. One such complex was in the city of Toulouse, France, which an enthusiastic Gaudí visited on one of his few trips abroad. Despite the fact that the Frenchman was much older than Gaudí, some of the inhabitants of the medieval town seem to have taken him for Violet-le-Duc himself when they came across him absorbed in running his hand along a wall. This anecdote shows that the young student had retained the same gifts of observation that characterized his early childhood. He would not lose them as an adult architect, one who actually needed to touch the materials of his buildings in the day-to-day dealings with his work.

One of the first commissions Gaudí received as an architect was an urbanistic project for the workers' houses in the cooperative of La Obrera Mataronense. The architect was enthusiastic, but the project was never to materialize fully. In 1878, however, it was shown at the Spanish pavilion of the Universal Exposition in Paris and impressed Eusebi Güell, an important Barcelonan merchant who would become Gaudí's friend and mentor. The architect Joan Martorell, for whom Gaudí had worked as an

In this photograph, Antoni Gaudí is part of a procession leaving Barcelona Cathedral. Because it is one of the few known photographs of him, it has come to be the one that has most marked the popular image of him. Here he becomes the architect with the white beard and the deep, serene, concentrated gaze. This cathedral was one of the buildings Gaudí most admired, and whenever he could he went inside to enjoy the fascinating interior, one of the most important of the southern Gothic.

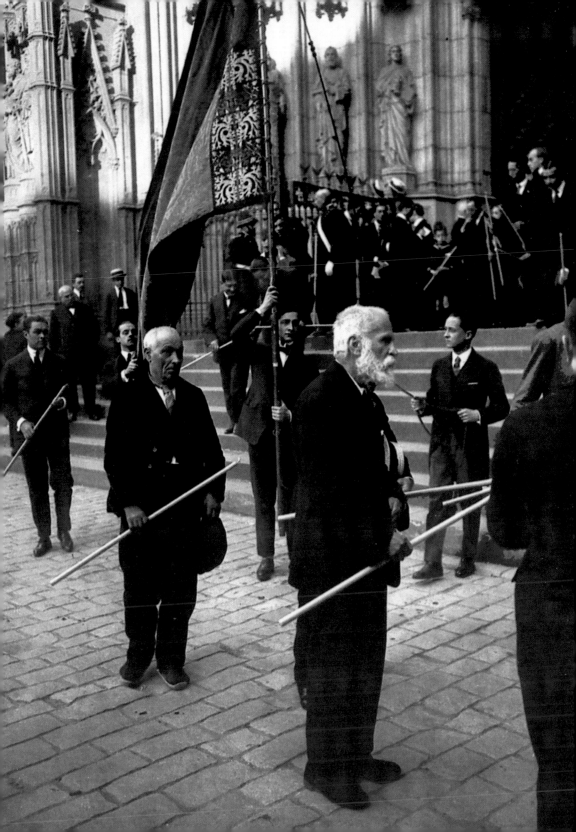

assistant, introduced the two men, giving rise to a close and fruitful friendship. In addition to commissioning Gaudí's many projects, Güell was one of the few contemporaries who admired and understood his work. They were from different social classes, but the two men shared the same social and religious ideals as well as a very profound sense of patriotism. Both believed in a more just society, influenced by the ideal English cities and by authors like Ruskin, the thinker and designer who put into practice one of these ideal communities and whose books were in the possession of Güell, who undoubtedly lent them to Gaudí. Both men, again, professed a sincere religious sense and fervently defended the Catalan language and culture, even when it was prohibited. Gaudí even went to the extreme of refusing to speak Spanish to a policeman,even though it meant arrest and two nights in prison. Francesc Pujols, in his "La visión artística y religiosa de Gaudí" (Gaudí's Artistic and Religious Vision, 1927), observes that the architect hardly understood Spanish and did not know how to speak it, making the services of an interpreter necessary when he was present for visits to the Sagrada Família, as happened with the visit of the king.

In 1883, work began on El Capricho and on the Casa Vicens –the buildings considered Gaudí's first houses– at a time when he was also in charge of the work on the Sagrada Família. He would continue to work on the church for thirty years, during a prolific period in which he became a part of the fervent Barcelonan society of the turn of the century. He always dressed according to the latest fashion and became the preferred architect of the city's rising bourgeoisie, with a reputation for being eccentric and brilliant.

In 1914, the architect decided to dedicate himself exclusively to working on the temple of the Sagrada Família. Apparently it was at this time that his lifestyle slowly changed, growing progressively austere. He abandoned, the luxurious suits and hats that had so characterized his style and returned to the simplicity of his childhood. In the last period of his life, he moved his living quarters to the foot of the temple so dedicate all of his time to the work, which now became the only thing he gave any importance to.

On the day of the fatal accident that would cause his death, Gaudí was so poorly dressed that when a tramcar hit him no one recognized the architect. He was misidentified as with a beggar because of his ragged clothing and because he was carrying no identification documents. Two days later, on June 9, 1926, Antoni Gaudí died in the Hospital de la Santa Creu, a hospital for transients and people with no means, after having dedicated the last 12 years exclusively to what was known as "the cathedral of the poor," thus faithful to his own observation that his place was among the humble.

Gaudí's creativity was inexhaustible, manifesting itself in the smallest details in all of his work. His genius and professional touch allowed him to work with all kinds of materials. He knew a wide range of industrial arts techniques and enjoyed working beside those engaged in the project. In these details from some of his works, the extreme delicacy and care in achieving the perfect finish can be appreciated.

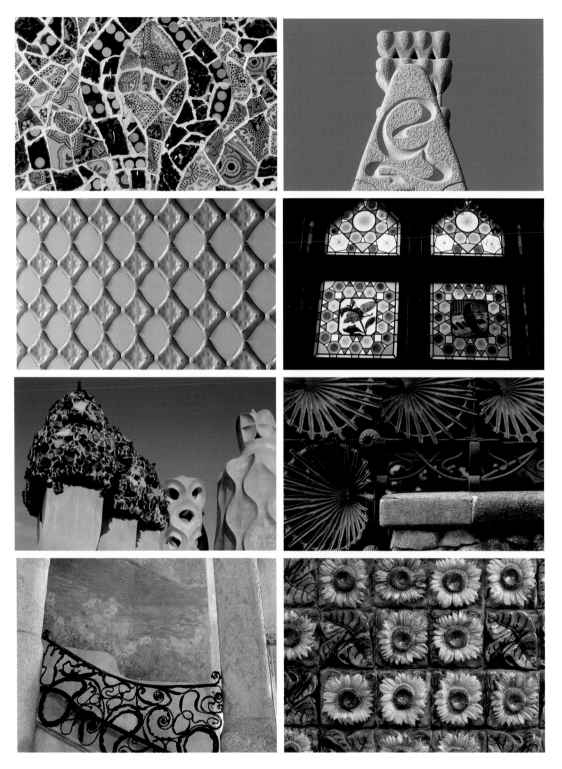

CASA VICENS 1883–1888

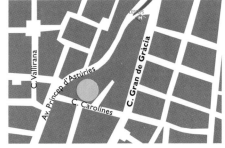

Carolines, 24–26, Barcelona

In 1883, a young Gaudí received one of his first commissions as an architect. Although the work of a beginner, Casa Vicens shows the imagination, sensitivity, and skill of a creative mind. The house is a prodigious construction that blends Spanish architectural forms inspired by the medieval age with elements of marked Arabic cut. The latter, indeed, are more in keeping with Mudejar art than with the architecture of the time, where the French school set the trend. The project, commissioned by the tile and brick manufacturer Manuel Vicens, involved building a summer residence with a garden. The house was to be built on a site that was not very large and needed to incorporated with traditional structures.

The architect conceived Casa Vicens as a subtle combination of geometrical spaces. This would skillfully and ingeniously resolve the use of horizontal bands in the lower part of the building and the vertical lines accentuating the glazed ornamental tiles in the upper part. In 1925, the architect J. B. Serra Martínez, respecting the original forms and colors used by Gaudí, built an extension to the house.

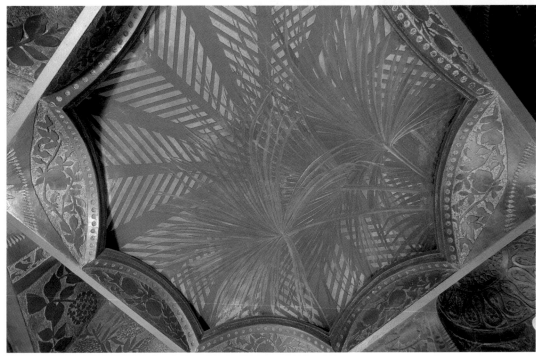

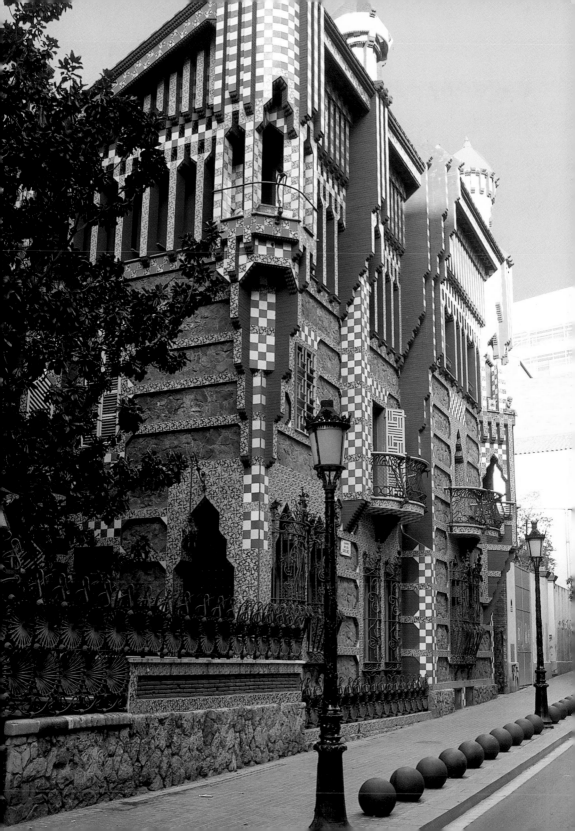

Sagrada Família

1883–1926

In 1877, the congregation of the devout of San José, led by the bookseller Josep Maria Bocabella, began the construction of a large temple financed through donations. The architect Francisco de Paula del Villar, who offered to draw up the plans free of charge, designed a neo-Gothic church: three naves with a crypt orientated along the site's orthogonal axes.

The first stone was laid on March 19, 1882. Villar stopped directing the work the following year, after disagreements with the budgetary committee. Joan Martorell Montells, director of the committee, recommended Gaudí who, at the young age of 31, took over responsibility for the project. In 1884, he designed his first plans and work on the elevation and the altar section of the Saint Joseph Chapel began one year later. In contrast to Villar's neo-Gothic project, Gaudí envisioned a church with a wide variety of technical innovations based on a plan of a Latin cross superimposed on the original crypt. Here, the main altar was surrounded by seven chapels dedicated to the suffering and sins of Saint Joseph. The transept doors were dedicated to the Passion and the Nativity. The main front, which opens onto the Mallorca street, was dedicated to the glory of Christ. Over each front, four towers are set for a total of twelve, representing the apostles. In the center is a tower symbolizing Christ, around which are arranged four other towers dedicated to the evangelists and one to the Virgin Mary. The sculptures were designed by the architect and carved by renowned artists of the time.

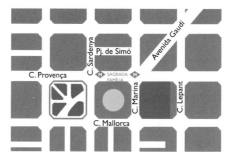

Plaza de la Sagrada Família, Barcelona

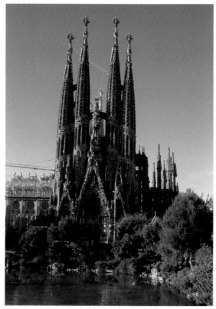

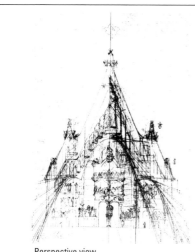

Perspective view

Study of the church

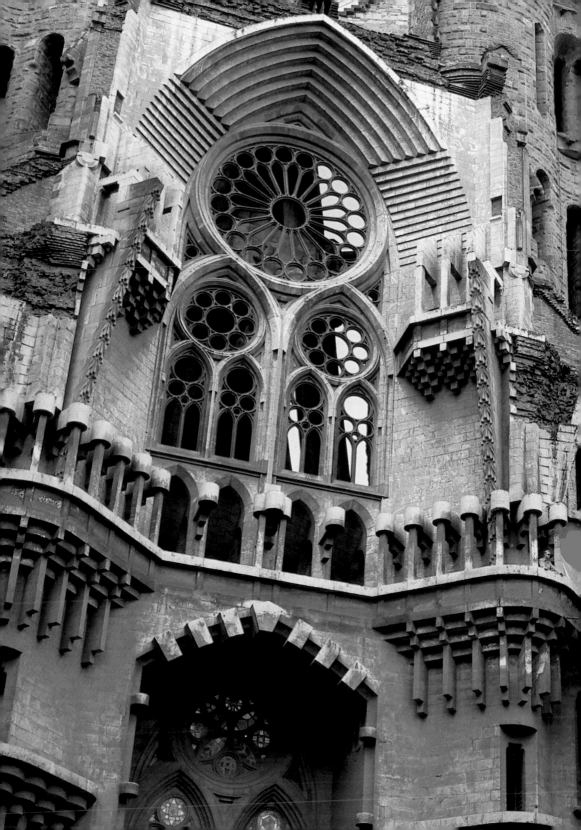

PALAU GÜELL 1886–1888

Nou de la Rambla, 3-5, Barcelona

Declared a World Cultural Heritage building by UNESCO, the Palau Güell, another project commissioned from Gaudí by Eusebi Güell, is the work that allowed the architect to abandon his anonymity. He designed this residence without skimping on materials and without a budget limit. In the construction, he used the best stone, the best wrought iron, and the best cabinetmaking. As a result, the house became the most expensive building of its time. The plain stone façade gives no indication of the grandeur of the interior, where Gaudí displayed a unique example of luxury. More than 25 designs were drawn before the definitive façade was decided upon, resolved through the use of markedly historicist lines and subtle classical echoes. Two large doors in the shape of parabolic arches allow the entry of carriages and pedestrians into the building, which has a basement, four stories, and a flat roof. To reach the basement, where a stable and a room for the groom and the guard were located, Gaudí created two ramps, one for the servants and the other for the horses. The ground floor is grade level, and the main staircase presiding over the entrance is flanked by two vestibules. The stairs lead up to the mezzanine, the piano nobile, and the garret.

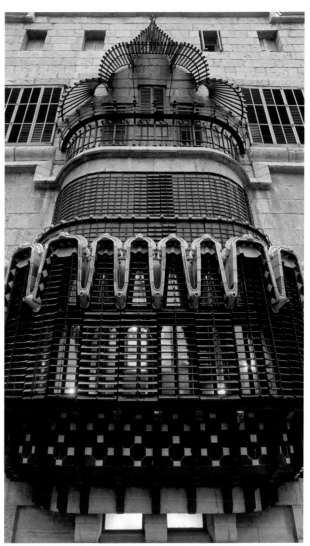

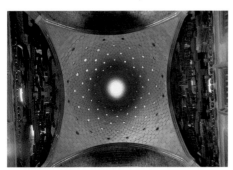

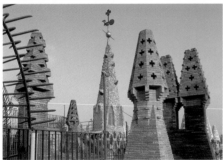

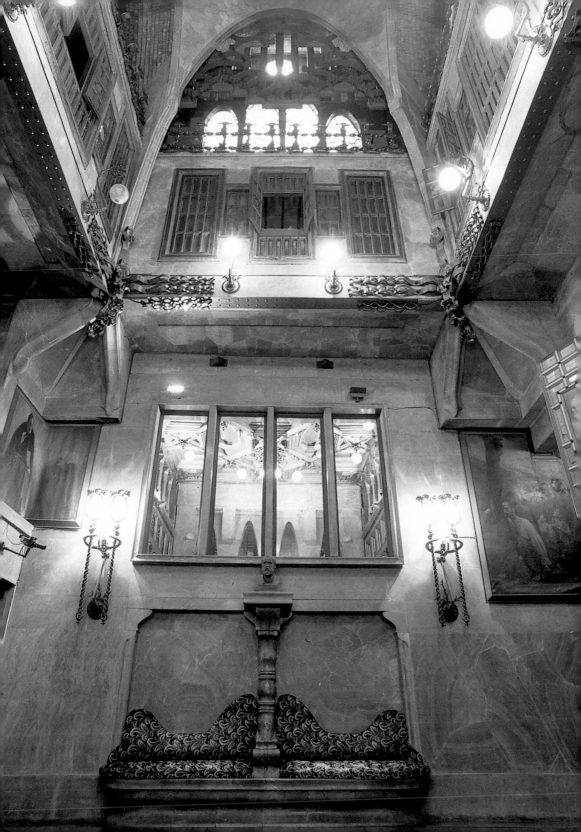

PARK GÜELL 1900–1914

Olot, s/n, Barcelona

Eusebi Güell, an admirer of English landscaping, had envisioned a new model of English city garden when he decided to urbanize the terrains in the Gràcia Quarter known as "Muntanya Pelada" (Bold Mountain). He commissioned his friend and protegé Antoni Gaudí with the intention of creating a residential space in the city that would attract the Catalan bourgeoisie, although in the end the initiative would not be as successful as anticipated. Gaudí planned the complex as an urbanization. Hence, from the early days of the project the space had a peripheral wall. This wall, curvilinear in form and with seven doors, is done in rubblework edged and incrusted with "trencadís," an ornamental ceramic tile rubble used repetitively in different elements.

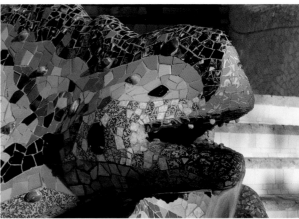

Opposite the entrance, a large double staircase leads to the Sala Hipóstila –comprised of 86 classical columns– and to the Greek theater, an esplanade above the Sala marked off by a continuous bench of flowing curved lines. The flights of the stairway are separated by small landings is decorative organic elements. One element is in the form of a cave, another is a reptile's head protruding from the coat-of-arms of Catalonia, and the third is the figure of a dragon.

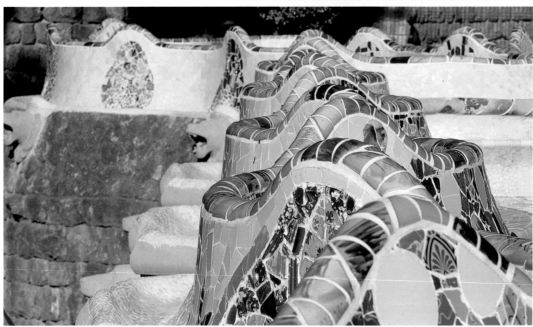

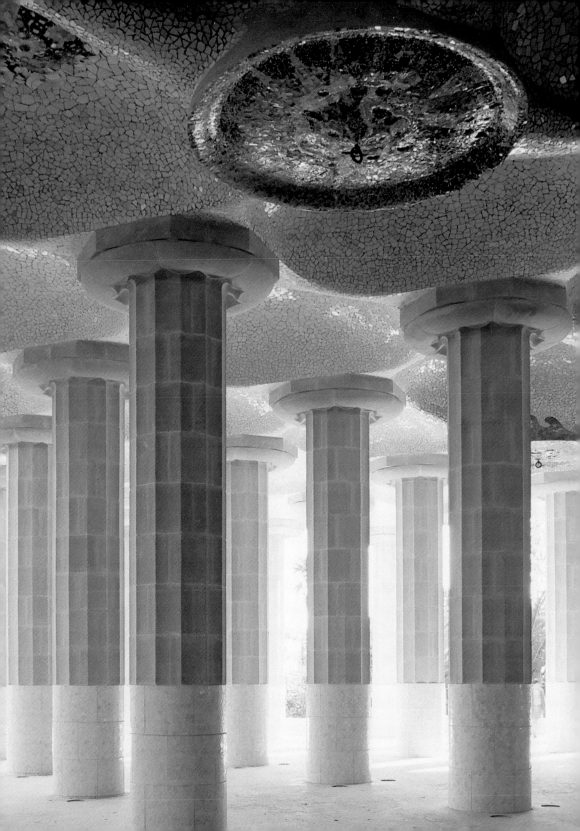

THE CRYPT OF COLÒNIA GÜELL 1908–1916

Reixac, Santa Coloma de Cervelló, Barcelona

The Colònia Güell is one of Gaudí's most original and interesting works, even though the project was never completed. Gaudí spent almost 10 years studying the plans. Construction began in 1908, but he was only able to complete the crypt of the church, a small fragment of a majestic project. When Count Güell died in 1914, the project was abandoned.

Gaudí's design takes advantage of the land's pronounced slope to include a crypt with a portico and a chapel, reached through the steps on the portico. The crypt is a complex and perfect skeleton made out of brick, stone, and blocks of basalt. Its floor plan is shaped like a star, made possible by the inclination of the exterior walls. Since the crypt is covered by a vault walled up with long, thin bricks on brick supports, it looks like the shell of a tortoise from the exterior. Inside, it seems to more closely resemble the enormous twisted skeleton of a snake. Four inclined columns of basalt situated at the entrance invite visitors to enter.

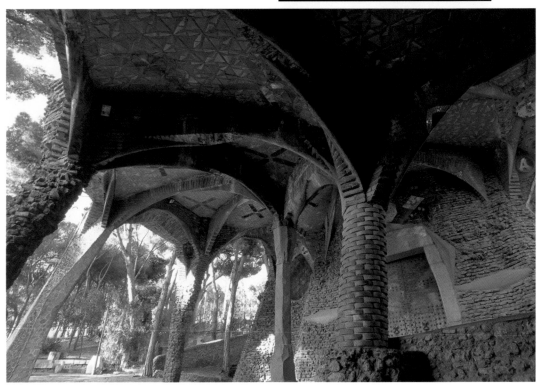

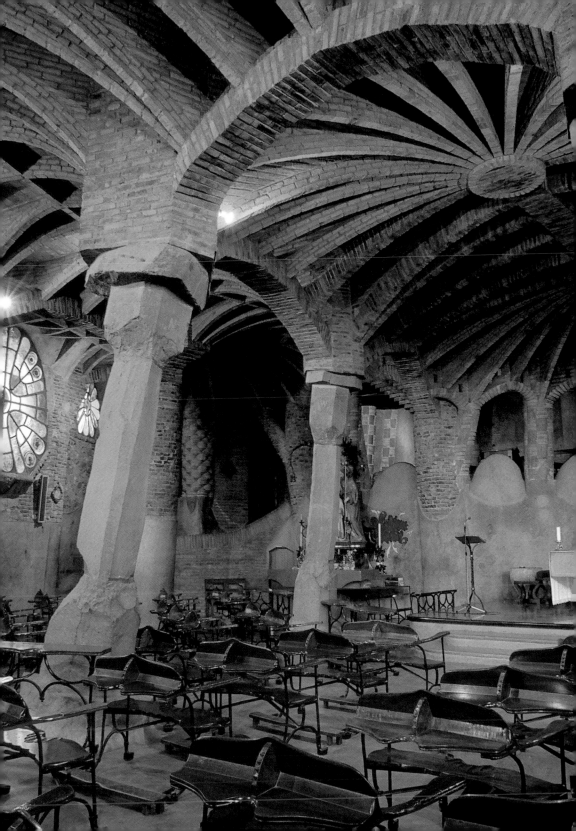

CASA BATLLÓ 1904–1906

The owner of the Casa Batlló, the textile manufacturer Josep Batlló i Casanovas, commissioned Antoni Gaudí to refurbish the façade and to rearrange the light wells in this building on Barcelona's Passeig de Gràcia.

The compositional sensitivity of the whole can be appreciated from the exterior, which is faced in Marés stone and glass on the lower floors, and with ceramic disks on the upper ones. While work was in progress, the architect himself decided from the street the optimum position that would allow these elements to stand out and give maximum reflection while the builders put them in place. The garret roof culminates the poetic development of the whole front: rose-colored ceramic tile pieces arranged like scales, and roofing tiles of spherical and cylindrical pieces evoke a dragon's back. A large tower with a small convex cross sets off this building which, in spite of its innovative geometry and color, takes into account the location in which it is located and the height of the neighboring buildings. On the roof, the chimneys and water tanks are faced with pieces of glass and colored ceramic tiles on a mortar base.

Passeig de Gràcia, 43, Barcelona

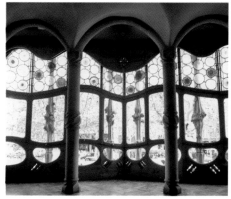

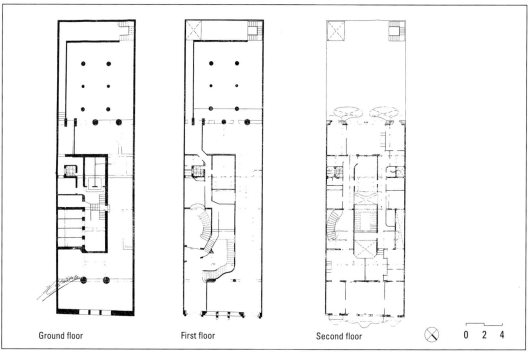

Ground floor First floor Second floor 0 2 4

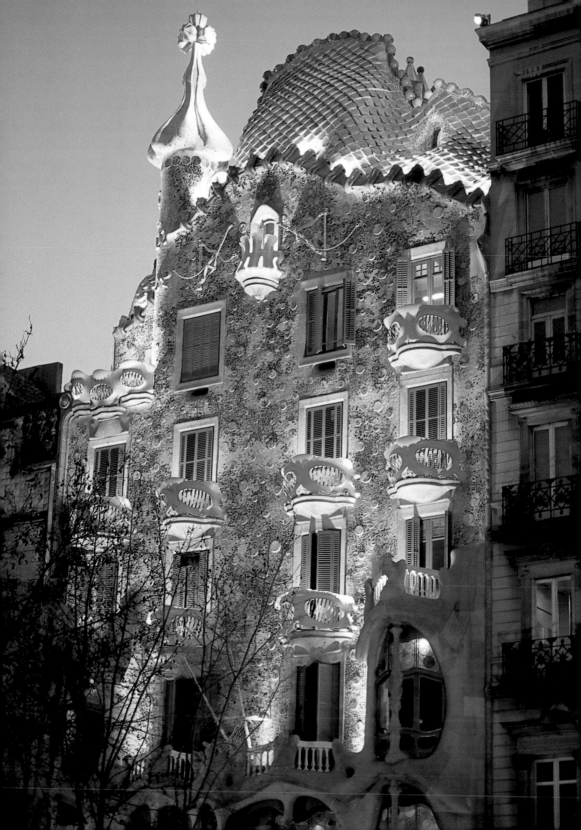

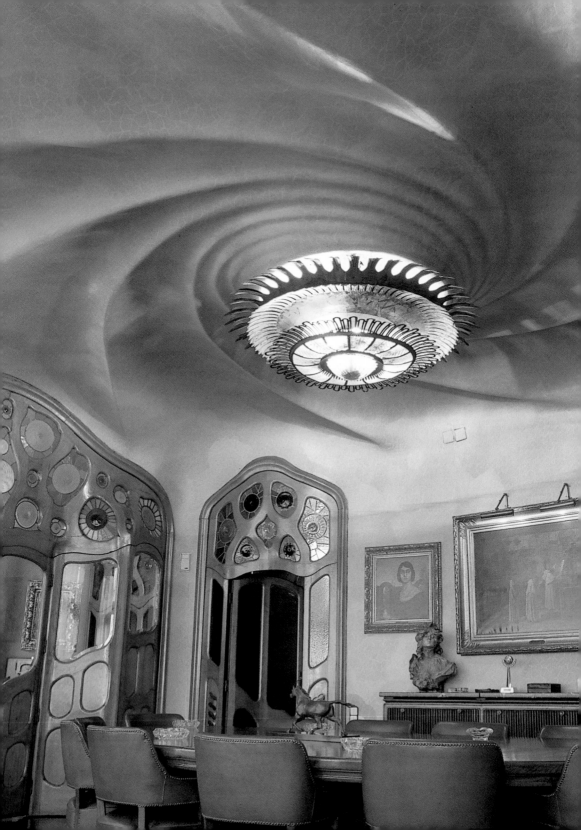

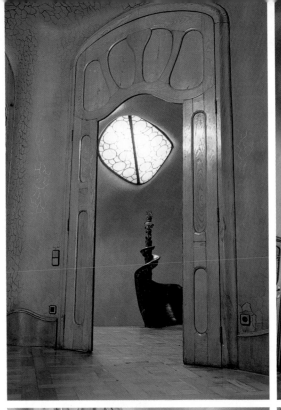

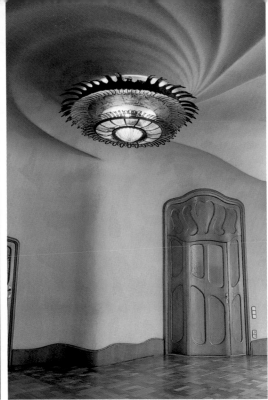

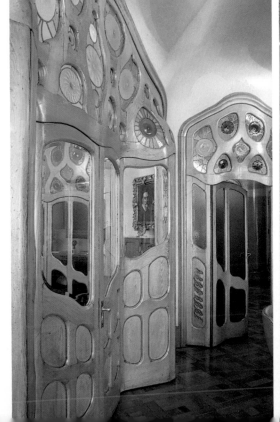

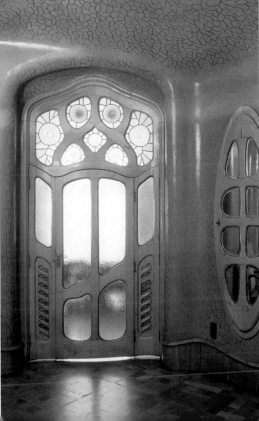

CASA MILÀ 1906–1910

The Casa Milà rises up like a great rock formation and this, from the moment of its construction, inspired Barcelonans to nickname it La Pedrera (Stone Quarry). The project was commissioned by Pere Milà and his wife, Rosa Segimon, to build what would be Gaudí's last work of civil architecture. After finishing the Casa Milà, he would exclusively dedicate himself to work on the Sagrada Família. As the Casa Milà is a building of very large dimensions, Gaudí worked out a system to save materials. First, he substituted load-bearing walls with a system of beams and columns, taking detailed care with the ties so as to reduce their girth. In addition, he visualized a façade of heavy appearance that was in fact made up of thin limestone plates from El Garraf (the lower part) and from Vilafranca (on the upper stories). The amount of steel used made more than one structural expert tremble. The whiplash shapes of the façade, often compared to a sea tide, correspond to the inside of the building with the total absence of right angles and by moveable partitions and details drawn down to the last millimeter. A good example of this careful design is seen in the ceilings, with different images traced in the plaster, including the foam on the waves of the sea, the petals of a flower, or the tentacles of an octopus. Also noteworthy is the minute artisanship, as in the wrought–iron work of the balconies or in the hydraulic mosaics.

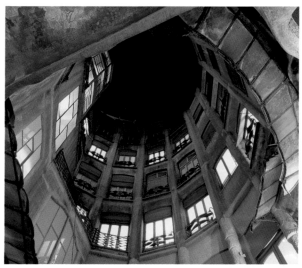

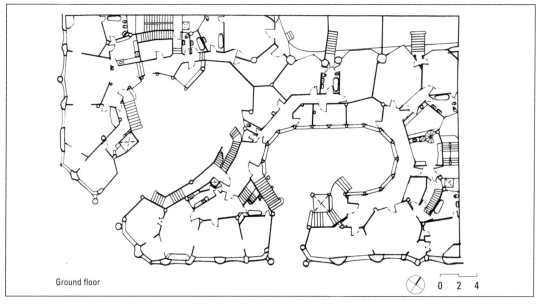

Ground floor

0 2 4

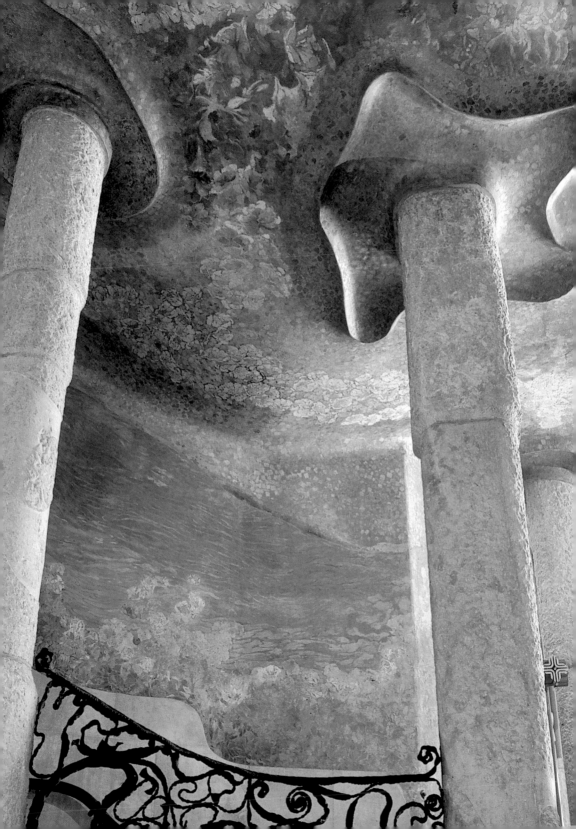

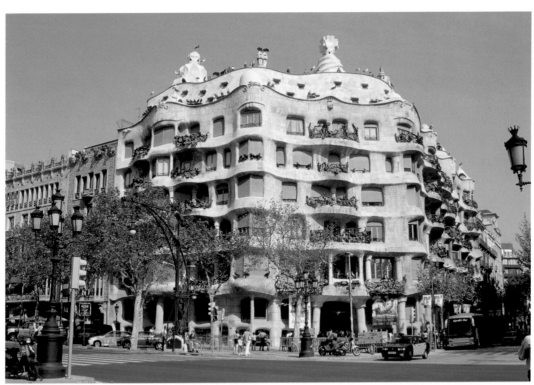

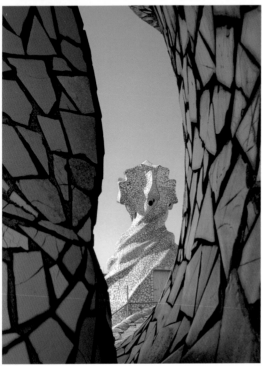

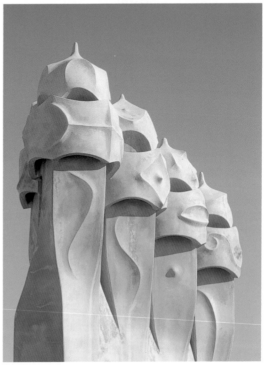

GAUDÍ-DALÍ

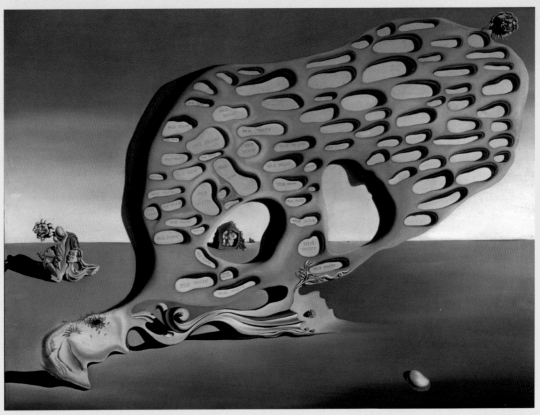

The Enigma of Desire: my mother, my mother, my mother
1926. Oil on canvas (43.31 x 59.33 inches)

SOFT FORMS AND HARD FORMS

Malleable material

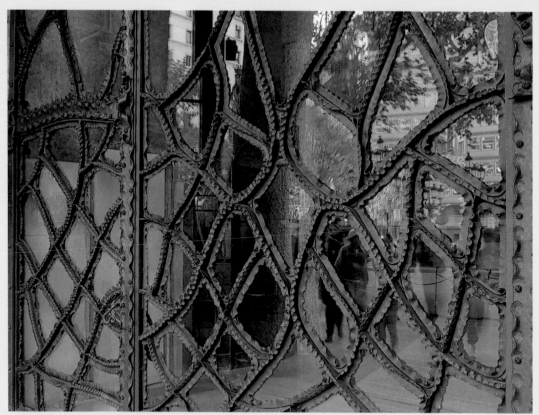

Main entrance to the Casa Milà, La Pedrera
1906–1910

When asked by Le Corbusier what the architecture of the future would be like, Dalí answered, "Soft and hairy, like Gaudí's." It may be difficult to find hairs in Gaudí's work, but his soft quality is indisputable, which makes clear both Dalí's admiration for the Catalan architect and his dislike of mechanization and the coldness of the modern architectural movement.

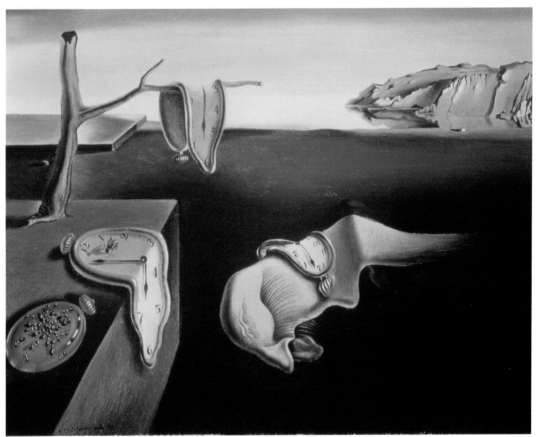

The Persistence of Memory (or Soft Watches)
1931. Oil on canvas (9.45 x 13 inches)

The Daliesque universe is not as hermetic as it might seem at first sight. In addition to repeating many of the same elements in different paintings, allowing viewers to make their way into his world little by little, Dalí wrote a great deal. His texts are always a good resource when decoding his work. They explain what he called his theory of the soft and the hard: the soft is the edible and, thus, what can ripen and, in the end, putrefy. In sum, the organic; life. At the same time it can digest knowledge and understand, in contradiction to the hard, which is the impenetrable in all senses: there is no human way —never better expressed— of comprehending it. It is inscrutable for the human mind and immutable in space and time. The rocks of Cape Creus and the almost desolate landscapes of the Ampurdán plain are examples of this quality of impermeability that characterizes the hard. They are spectral elements, often disquieting because they appear to conceal

something in their apparent simplicity, something viewers cannot discover no matter how long the oil painting is studied. The soft acts in a diametrically opposed way. It is also unsettling, but not because of what it conceals; it is disquieting rather for what it reveals. That flesh is considered soft tells us that no matter how hard we try to hide it under clothing, humans are made of flesh, a flesh edible and perishable. Faced with a everyday but softened image such as the human body or a musical instrument, Dalí creates a completely unexpected quality regarding this object, thus provoking a certain unsettling effect, a contridiction of the most basic reality surrounding us. He shows us briefly the crudity of its interior: what we know will perish with us; what we don't know and can never understand will survive.

It is not strange that Dalí admired Gaudí so much. For him, Gaudí's architecture was a soft architecture, edible, full

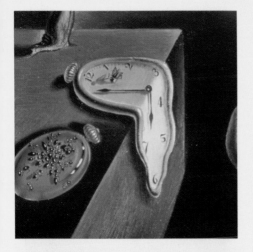

The image of soft watches has many connotations. Dalí not only related this image to the impossibility of measuring life time in a Cartesian way, he also included the scientific discoveries of the era proving that time is not an unchanging constant. Dalí portrayed a conception of human time over and above the cold, constant measuring: the second itself does not happen in the same way if one is waiting for a train as when one is fully engaged in the act of sex.

The image of a Camembert cheese long ripe, almost completely melted, is what inspired Dalí to represent the soft watches. Undoubtedly, all his reflections on time are sudsequent to the execution of the picture, but this in no way weakens the power of the image or the argument.

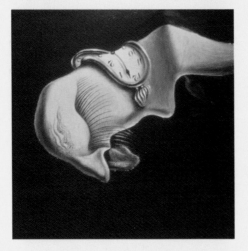

The figure that appears here as well as in *The Great Masturbator* and other pictures acts as a sort of double for Dalí himself. As in the other works, here it has a soft and morbid texture, clearly contrasted with the rocks in the background, typical of the Ampurdán seashore.

The power of this image is due not only to its pictorial quality but also to Dalí's intellectual capacity, able to imagine and to argue a solid personal world. Not only his theory of the soft and the hard sustains the piece, but also all of his reflections on the works of Freud. This subtending idea is clearly perceived in Salvador Dalí's written work which, in addition to revealing his ideas, is a literary work very much in its own right.

The Casa Milà project was designed as an ode to the marine world and the sea, from the sweeping wave of the façade to the most minute details including the columns meering the ceilings with the plaster wrapping the capitals, as if they were immersed in a watery mass.

The nickname given this building by Barcelonans is La Pedrera, which means stone quarry. Dalí liked this apparent contradiction between the devastated rock and its wavy, watery forms, what he interpreted as a contrast between the soft (marine undulations) and the hard (stone) appearance.

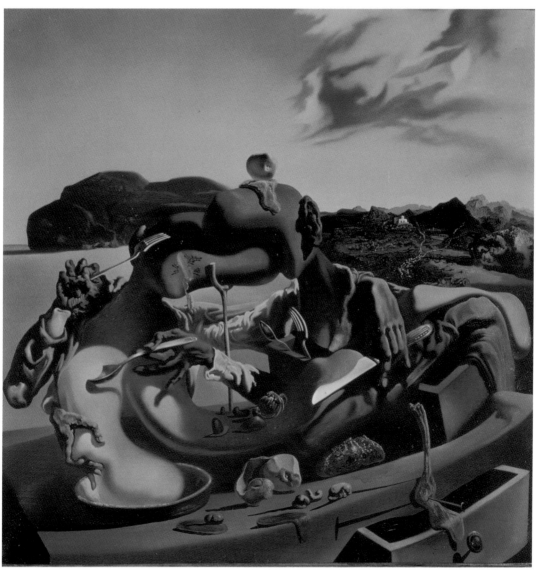

Cannibalism in Autumn
1936. Oil on canvas (25.6 x 25.7 inches)

of symbolism and absolutely vital. Gaudí's personality is portrayed in each of the stones of his buildings, from the deepest religious obsessions to his unbounded creativity. The capacity to awaken many different interpretations –from the edible to the religiously credible– is perhaps the characteristic that most pleased Dalí. It permitted him to make a paranoic-critical interpretation of the works of this architect who sculpted soft poems with hard stones.

It is unfortunate that Gaudí's workshop, installed in the crypt of the temple of the

Sagrada Família, burned down during the Spanish Civil War in 1936. Nevertheless, thanks to photographs and to descriptions from those who knew and worked with him, we can approximate his work method. Gaudí was a person who, was dedicated to study and to making all sorts of maquettes. Many of these were of plaster, as is shown by the photographs of the scale-model columns for the temple of the Sagrada Família. The construction of these columns was not begun until 1990, given the difficulties inherent in the work

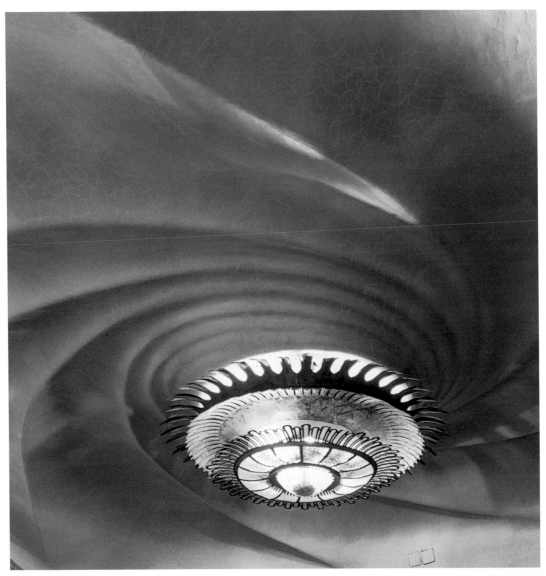

Ceiling of a room in the Casa Batlló
1904–1906

and the sluggishness with which the project advanced. Seeing the columns today, it isn't strange that the architect used plaster for the scale-model because the columns don't have a single straight line in them.

Gaudí's buildings give the impression that they're not made of stone but rather of clay or plaster. This is a quality that characterizes his work. Anyone can appreciate standing before a block of stone, often one of considerable size; yet the impression is one of total weightlessness.

No one has ever built towers like those of the temple of the Sagrada Família, so ethereal yet with an undeniable power of architectonics, like a mountain in the middle of the city. In this way, Gaudí work reflects the 'soft' sensiblity discussed by Dalí.

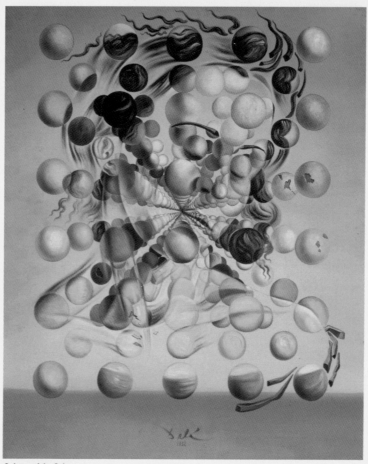

Galatea of the Spheres
1952. Oil on canvas (25.6x 25.6 inches)

FRAGMENTS AND TRANSFORMATIONS

The appearance of new images based
on fragments

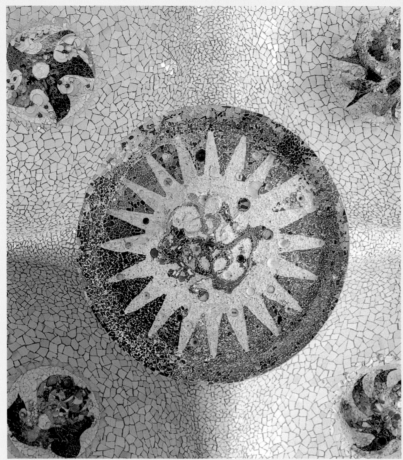

Park Güell
1900–1914

To create a totally new work of art without parallel in its immediate environs, it appears that both artists needed to destroy the established in order to re-work its ruins. Gaudí broke with the formal norms to develop his architectural style while Dalí's paintings contradicted every pre-established convention. Both irrevocably transformed their respective fields: they worked untiringly to understand their world and the techniques of their métiers. From that point, with complete training, they would develop painting and architecture toward their visions, making their particular world a universal opus.

The Great Paranoiac
1936. Oil on canvas (24.4 x 24.4 inches)

The collage, a technique that consists in bringing different outside items into paintings, is one of the great contributions of twentieth-century painting generated by Cubism and contemporary art movements.

Over the last few years, Gaudí has come to be regarded as a precursor of this technique because of his use of *trencadís* (ceramic rubble). Picasso, whose collages with newspaper clippings glued to the canvas are perhaps the most widely known examples of collage, admired the *trencadís* technique during his formative years in Barcelona. The material is a collection of fragments of tiles broken in to small pieces and covering, jigsaw-puzzle style, some of the building's surfaces. This technique allowed Gaudí to work with glazed tiles without being limited to a flat surface. It also served him well in the creation of a colored mosaic ranging from the most capricious reification (the medallions on the columns in Park Güell) to the most amusing figurative work (the dragon fountain in the same park).

Glazed tiles have a very long tradition in the Mediterranean, from the Greek mosaics to the tiles on mosques. The use is well rooted in Catalonia from the times of Gaudí, a kind of reinventor who took classical mosaics toward the modernity of collage.

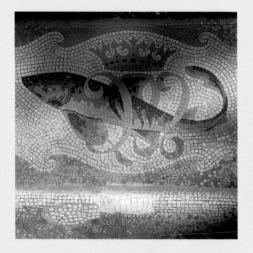

The mosaic on the entrance to Bellesguard represents a dolphin with four bars and a royal crown, clear allusions to the flag of Catalonia and to the extinguished royal house of Catalonia-Aragon. Bellesguard is built on the site of what was a small palace of the last king of the royal house of Barcelona, Martí l'Humà (the last king of the Catalan empire). Hence, there are many elements alluding to the country's glorious past. The image of the dolphin refers to Catalonia is past as a maritime power with domains throughout the Mediterranean; its power lay in the sea.

The mosaic is a technique that makes images from small spots of color called tesserae or tesselae, normally square in shape, like those seen here. This age-old technique should not be confused with *trencadís*, which makes use of large tiles broken at the factory, recycling them by breaking them into even smaller bits and forming colored images.

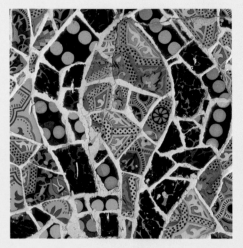

The *trencadís* tile work comes from many different sources. In this example, different styles of tiles are combined to create a totally new design. The contemporary feel to these collages is evident both because of the re-used material intended to be discarded and because of the image itself, lacking figurative references or regular abstract patterns, whether in edgings or in other ornamental motifs.

The attentive viewer that looks at the forms appearing in the *trencadís* on the bench in Park Güell will find pleasant surprises—not only ceramic pieces from many different sources like plates and bowls, but also tiny stars and beautifully crafted compositions.

This magnificent wall is in the hypostyle room of Park Güell , under the plaza. For this *trencadís*, Gaudí left free expression to his assistant Jujol, the most notable of his collaborators. The beauty and originality of this technique reaches its maximum splendor here. The construction generates great beauty from all types of materials, including glass bottles and different ceramics, seeking color combinations deserving of admiration. In spite of the dynamic of these pieces, the hypostyle is extremely serene, and is one of the most magical rooms in the whole park.

Raphaelesque Head Exploding
1951. Oil on canvas
(16.93 x13 inches)

Dalí is the undisputed master in creating double images, figures that merge into uncountable other images. They can be, for example, a woman, a lion, and something totally new all at once. Recovering a little known genre of baroque painting, which cherished these optical games, Dalí set out not only to establish an association of elements that can be read as double images but also to suggest the contents related to them. Hence, these paintings not only surprise by way of their visual richness but also —in any attempt at decoding them— by presenting themselves as a sequence of (arguably)

infinite ideas. The paranoiac-critical method Dalí concieved moves, in sum, along this path: not to pause and attempt to rationalize things to understand them, but to impel free association, conscious of the ideas that surge up while viewing the image and thus to apprehend the image in all of its facets.

It at times appears that Gaudí is capable of taking the collage to architecture. Not only did he work with extra-architectural elements (such as one of the chimneys on La Pedrera, covered with empty and sometimes broken champagne bottles), he also fragmented the most essen-

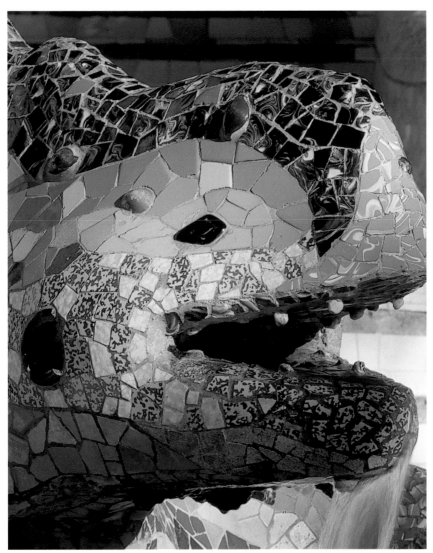

Park Güell
1900–1914

tial parts of architecture. He is one of the first architects to dare to separate the two function's assigned walls of bearing loads and enclosing space. An iron structure replaces the first function, which allows the architect to mold the walls to his fancy since they support no weight. The model for this concept is the Casa Milà. There, as in many other ideas, the Catalan architect was ahead of his time, and this construction system continues to be used today.

Dalí's work has no need to resort to collage. While it is true that in his training phase Dalí investigated all the trends in painting —and among them Cubism and collage— his mature work is not based on this formal study but on what he is able to communicate with his images. Although Dalí did not hesitate to work with photographs and to create sculptures from chairs and mannequins —what is called assemblage, a three-dimensional collage— his quest is not formal because what really interested him was the sensation and ideas that juxtapose different elements.

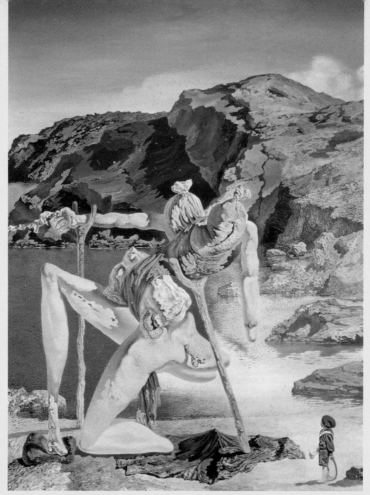

The Specter of Sex Appeal
1934. Oil on wood panel (7.1 x 5.5 inches)

NATURAL AND ARTIFICIAL

Crutches and columns to construct
a new world

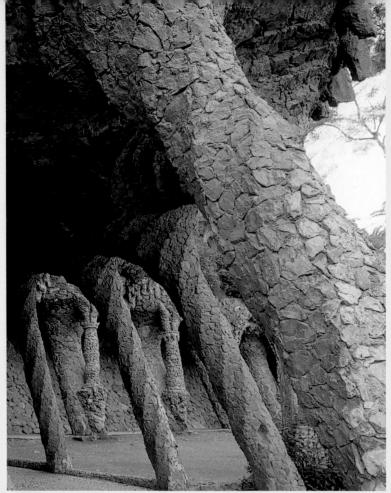

Park Güell
1900–1914

If Goya said that his only masters were Rubens, Velázquez and nature, Dalí and Gaudí considered nature as their basic teacher, although the concept of nature was diametrically different for each artist. Gaudí never tired of repeating that his great master was nature, referring to what today we understand to be the natural sciences. For Dalí, however, nature was not the exterior that surrounds us but the internal forces that move humans (the desire for life and death) and matter (the forces of attraction and repulsion in atoms).

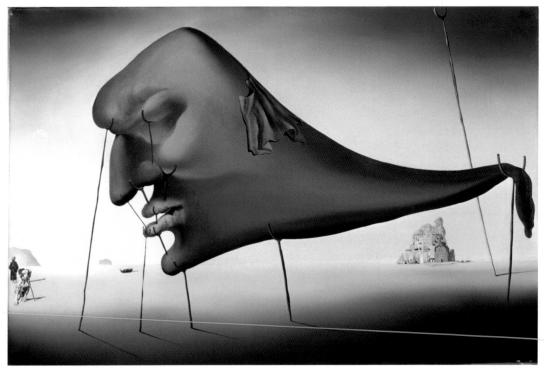

The Dream
1937. Oil on canvas (20.1 x 30.7 inches)

In the 1920s, Freud's ideas invaded Europe. They assigned a great importance to the explication of human nature through the unconscious and life and death instincts. Dalí's paradoxical associations depart from this conception. His fantastic world is born of the quest to awaken the unconscious, starting with, very concrete images that are repeated in his body of work. One of these obsessive elements is the crutch, an object that will appear in the Daliesque imaginative world at a very early age. In *The Secret Life of Salvador Dalí*, he explains how the crutch he found in the attic of his childhood home became his favorite toy. It fascinated him to lean his cheek on the axillary part, covered in cloth, since it was forked and of a soft texture, and fit the roundness of his young face.

This type of crutch proliferated in Europe because of the many amputees coming out of the First World War. Dalí read, in 1922, Freud's *The Interpretation of Dreams*. From that point, he set out on a full investigation of the unconscious and sought in different elements the connotations of forbidden themes or social taboos to disquiet and awaken the unconscious.

In the case of the crutch, his connotation is the amputation of a leg.

But there's more to this. He introduced this element into his personal imaginary world, extending its significance. The crutches do not appear only as objects with a real purpose, they take on different uses, propping up flaccid bodies finding their way among inanimate bodies or sleepers. A strange world, repulsive yet curious, is here Dalí's genius come's in: objects that are of little artistic merit in and of themselves will be put into settings that are surprising that seek to awaken the deepest and most hidden human sensations. There may not even exist a way to name the reactions, but they include: strangeness, repulsion and attraction, tension, and disgust.

Gaudí also struck his age as strange to the extent that he investigated the conception of nature—although of course he had nothing to do with the genius from Cadaqués. The architect appeared strange not through inspecting the unconscious but by setting out to build according to the laws of nature. There were no crutches in his building's but twisted columns, and buttressing that resembles

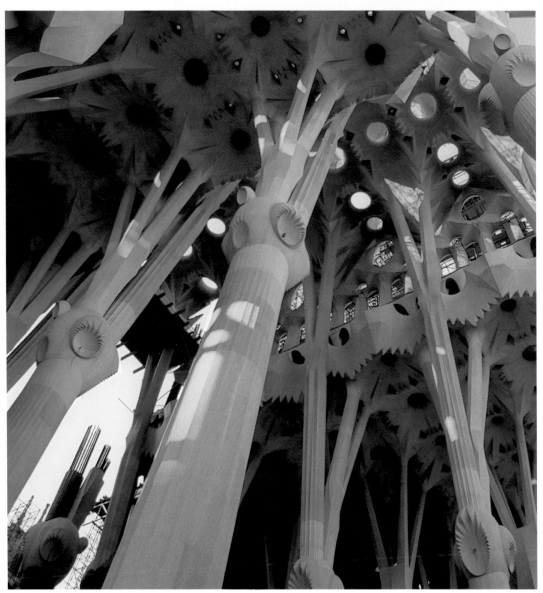

The temple of the Sagrada Família
1883–1926

the organic forms of trees more than a pillar of human making, do appear.

In all of Gaudí's works we find signs of this search for natural laws. One of the most characteristic elements of the architect's pieces is the parabolic arch, which better distributes force and is the base of many natural frameworks.

Park Güell perfectly exemplifies the use of elements that reaffirm this sensitivity toward nature. The project– never fully realized– intended to create a city garden

where the natural world and the artificial blended. In the middle of the park is a large unpaved plaza supported on columns. The space, which was to house the market and be the social and recreational center of the residential zone, is perfectly integrated into the natural slope of the hill. This conflation of natural and artificial elements survives to the extent that the plaza still acts as a large collector of water, which is piped through the columns to an underground tank that

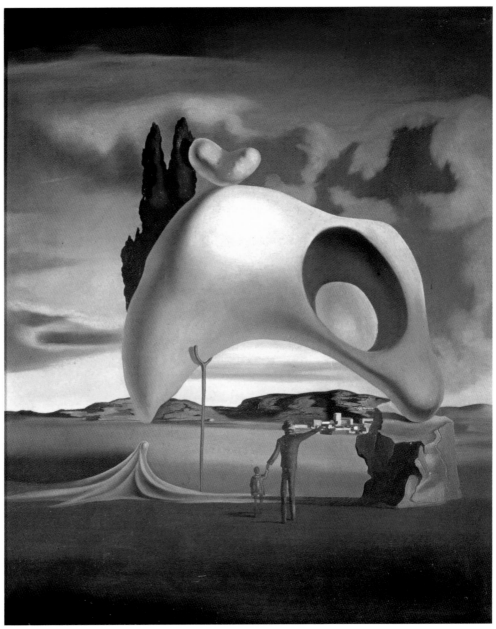

Atavistic Traces after the Rain
1934. Oil on canvas (25.6 x 21.26 inches)

would have supplied the park.

Also surprising is the delicacy with which Gaudí approached the road crossing the park. There are areas where it is raised on columns, creating a viaduct. With this, Gaudí, in addition to creating a space from which to enjoy the spectacular views of Barcelona, intended to respect the natural geography as much as possible. The columns of these viaducts perfectly mimic the trees around them, not so much because they are twisted and made of devastated stone, but because they share the same internal structure.

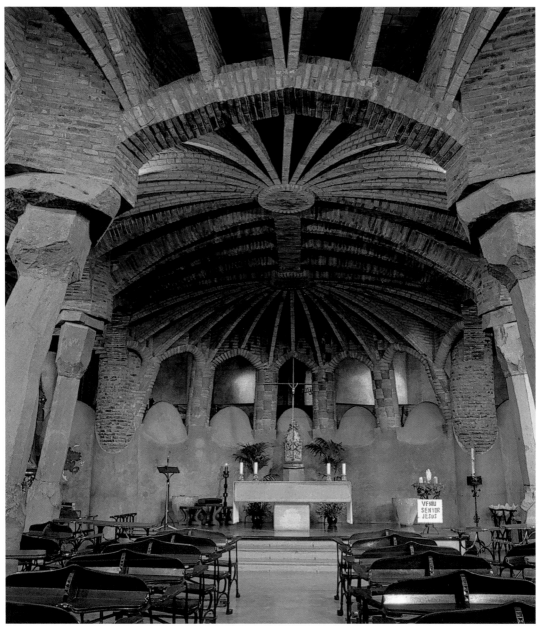

Crypt of the Colònia Güell
1908–1916

The Crypt of the Colònia Güell is an example of pure balance, with the arches and columns forming a skeletal frame. The different pieces here only work in relation with the others, and the dynamic stress can almost be read in the interlacing work. The resulting harmony yields a feeling of weightlessness and unity much like that of Mediterranean Gothic architecture, which Gaudí greatly admired.

In *Atavistic Traces After the Rain*, a fragile balance is the major component of the composition: the landscape, the cypresses that bend earthward but never quite touch the ground, the Ampurdán yin-yang (the two white elements). The picture appears to be hanging by a thread, centered on the adult figure with the child, around which the entire landscape gravitates.

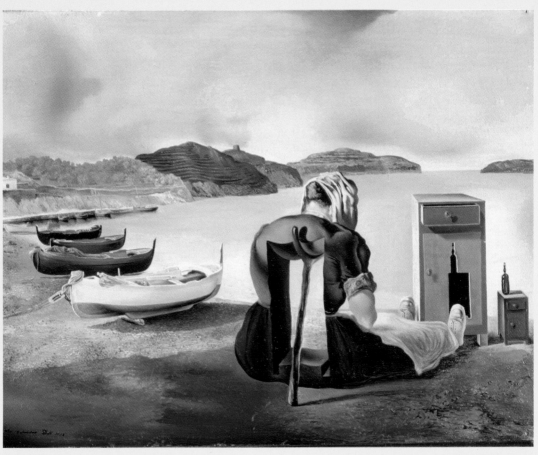

Weaning from the Food chair
1934. Oil on wood panel (7.09 x 9.45 inches)

EMPTY SPACES

Perforating stone and flesh

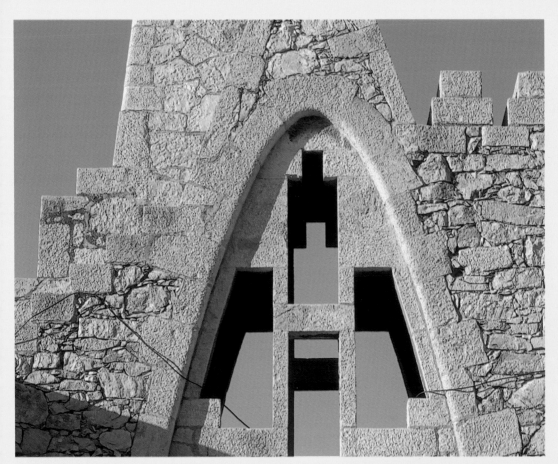

The Güell wine cellars
1895

In *The Secret Life of Salvador Dalí*, Dalí tells of the great impression his visit to Park Güell made on him as a child. The image of two columns framing Barcelona in the distance, produced an enormous unease in him and brought him to paint, years later, his nursemaid with avoid in her body, as if the night table beside it were cut out of her. Although it is very likely that Dalí gave this explanation as an adult, it is indisputable that there exists a close link between the two artists.

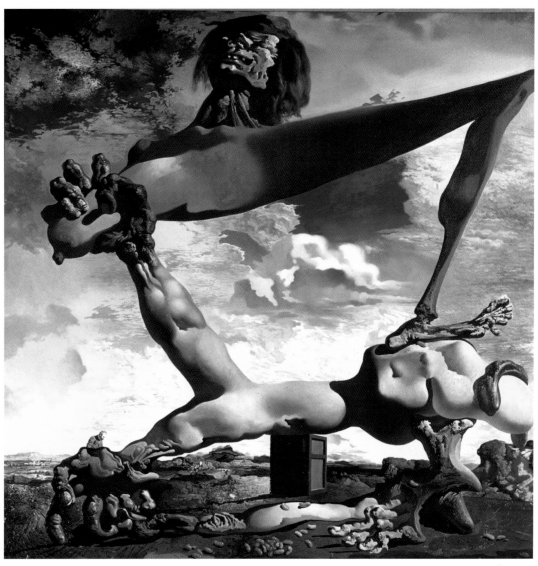

**Soft Construction with Boiled Beans
(Premonition of Civil War)**
1936. Oil on canvas (39.37 x 38.98 inches)

Gaudí always recognized that his father's trade had influenced his own training as an architect, since he learned from his father how to work with the notion of the full and the empty. Francesc Gaudí was a boilermaker, creating boilers and pots from flat sheets of metal. For Gaudí, the trade required the capacity to imagine a cubic body from flat materials or, seen somewhat differently, the capacity of creating a hollow from a solid metal object. This reflection, not unlike those of some of the important sculptors of the twentieth-century like Henry Moore or Eduardo Chillida, helps understand why his buildings sometimes appear to be sculptures, since the spatial concept is very similar. Because of Gaudí's technical training, he was able to make this reflection a reality, boring through the stone to create the most daring shapes and working the bays of each of his buildings like sculpted hollows. The architect's great imagination allowed him to create spaces that were totally new to his age, like his roofs and chimneys which are true sculp-

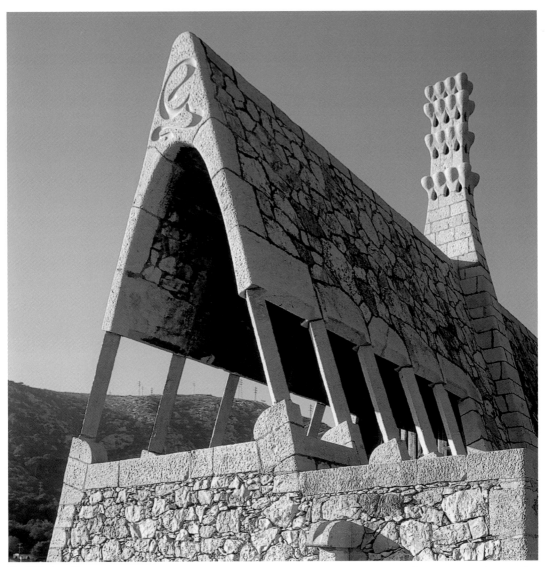

The Güell wine cellars

tures, like the subgrade spaces used as parking lots —the first in Barcelona— and veritable caves dug out of the buildings' entrails.

Dalí appreciated these modern qualities of Gaudí's. He was one of those who said that the architect was ahead of his time and that only the future would recognize his value. Like the Reus architect, Dalí often found inspiration in the natural environment —especially the landscape in his native Cadaqués— an environment that transmits the feeling of total emptiness. In

his works from the 1930s, the Ampurdán plain or the rocks of Cape Creus frame his superrealistic figures. They are recognizable places, yes, but only approximately so; at times it is impossible to find their exact location. These desolate spaces, populared by very few figures, vibrate. They not only frame the figures, they also transmit the feeling of a supernatural space concealing something alive and dangerous, much like other Dalí obsessions.

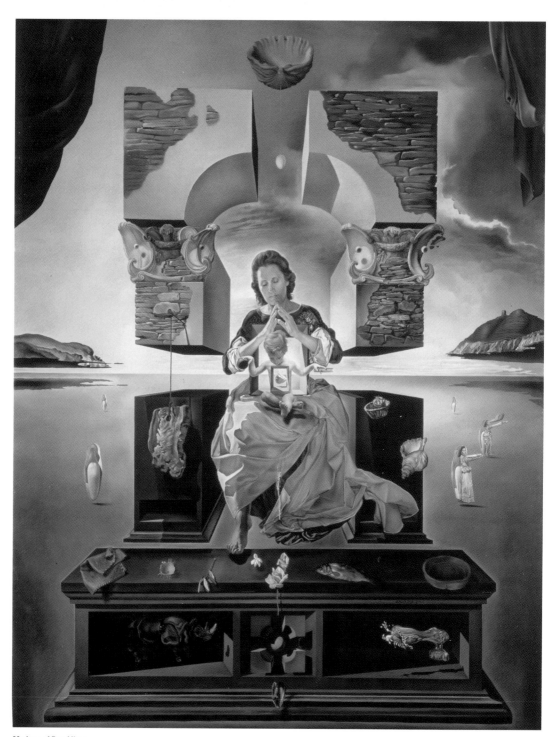

Madona of Port Lligat
1950. Oil on canvas (56.59 x 37.8 inches)

The theme of religion also is another of Dalí's obsessions in the post-World War Two years. It is a quest to represent the atomic forces of simultaneous attraction and repulsion –of atoms and, consequently, of objects. Part of the serenity and unity in the work of this period is due to the detailed study of the compositions. Not only do they recur in classical proportions, but the resulting tension brought about by no object touching another object, while in strict relationship with those around them, confers an incredible dynamic on the work. At the same time, the image appears frozen and unmoving. From this paradox, Dalí shows, once more, his unchallenged mastery.

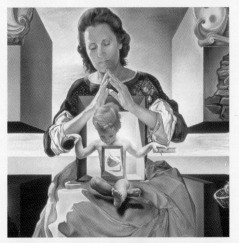

This picture is a fusion of the classical representation of the Virgin and Child and the highly un'orthodox representation of the sacred form, the body of Christ. Both the Virgin, with the face of Gala, and the Infant Jesus are represented with a large hole in their body. It is, as it were, a double tabernacle for the piece of bread that represents the body of Christ in the Catholic liturgy.

In spite of the strangeness of the subject matter, the work retains all the elegance a religious painting can have. Yet it is evident the morbid and cannibalistic quality of the piece of bread, simultaneously the body of Christ, is represented here not as martyr but as innocent child.

The interior of the dome on the Palau Güell is one construction that continues to generate interest today. The relatively small salon on the ground floor, designed as a concert room, became, as work progressed, a three-story salon crowned by a dome with small apertures, including an oculus in the center. These apertures, and the windows themselves, inundate the salon with daylight in fine gradations, conferring a heavy, serene atmosphere.

Gaudí immersed himself in the classical reference points of Saint Sophia in Constantinople (today's Istanbul) and the Parthenon in Athens in order to construct this dome. But once again, the Catalan architect's solutions are entirely personal, making this vault's hollowness defy gravity and turning it into a starry sky.

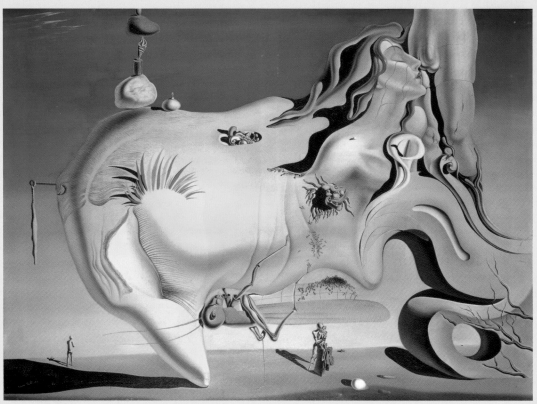

The Great Masturbator
1929. Oil on canvas (43.30 x 59 inches)

A SENSITIVE REALITY

From the sublime to the frightful

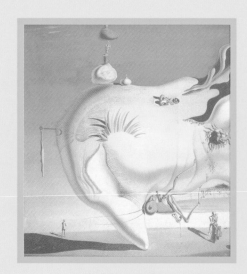

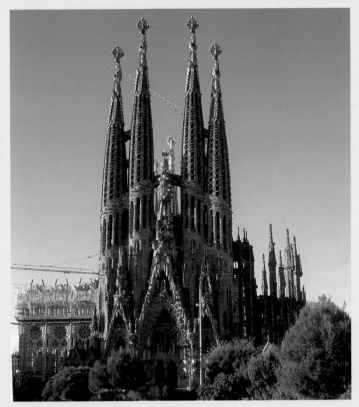

The temple of the Sagrada Família
1883–1926

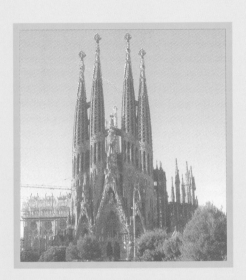

These two artists represent the primary exponents of the movement to which they belong, and at the same time they are unique and inimitable. They are devastating to the point of going beyond the imaginable, beyond their age, beyond their peers. At times it is impossible to judge some of their work because one cannot decide whether it is so ugly it is beautiful or vice versa; whether the work is so horrible that it is an artifact of genius. What is certain is that these works are absolute and surpass the person who looks on them; sublime.

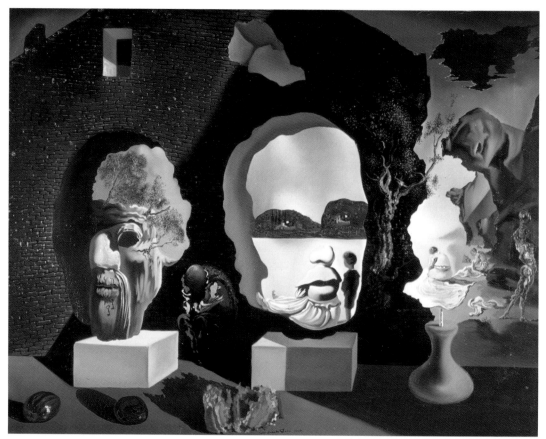

Age, Adolescence and Youth
1940. Oil on canvas (19.7 x 23.62 inches)

"¡El surrealismo soy yo!" (I am Surrealism!) With this emphatic statement, Dalí responded to his expulsion from the Surrealist group by André Breton. The French poet, acting on the accusation against Dalí of not being communist, expelled him as he had expelled other members of the group. Dalí was highly conscious that his separation from the Parisian group was inevitable, but conscious as well of his great artistic quality and of the fact that he was respected enough and well known enough to continue his career on his own. Breton himself admitted that when Dalí entered the group in 1929 he became one of its motivating forces, and that he was surprised by his sharp intelligence and the exceptional quality of his work. Although Dalí was an active member of the group, he held onto his strong personality and set his paranoic-critical method against the automatism of the French members who, while admiring Salvador Dalí, never understood him.

This strange relationship of need and indifference would be repeated in Gaudí's case. His work would be incomprehensible without the appearance of Art Nouveau throughout Europe, centered in Paris (yet without ever being considered in the debt of French art). Very important in Gaudí's art education was the theoretical books of Violet-le-Duc, the great re-discoverer of the Gothic and an architect of great prestige. Even in the Catalan architect's time in Toulouse, whose medieval city would be restored by Violet-le-Duc, Gaudí was taken for the French master because of his careful study of the walls. In spite of this connection to France, Gaudí's forms can only be explained by their particular ideas and by Gaudí's strong personality.

At the Paris exposition of the maquettes for the Sagrada Familia, French society did not know how to react. They could not understand what they were looking at, whether it was genius or a monstrous

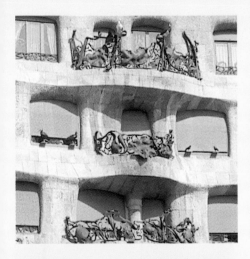

For Dalí, the balconies of La Pedrera were parted lips that reminded him of his nurse-maid's back. For him, the whole building was a live mass of eyes and mouths, and he always found in Gaudí's work links with his own. What gave Dalí most pleasure in the architect's buildings was the capacity to awaken the imagination. These are works that adapt themselves to any interpretation. They lend themselves to successively bringing up different images, in a way not far removed from Dalí's paranoic-critical method.

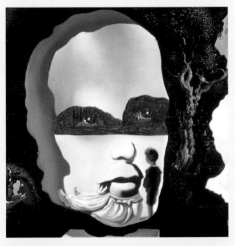

This picture revives the classical theme of the three ages, interpretable as a kind of vanitas. It explains, the vital human phases, reminding us that all humans grow old, moving inexorably toward death. The theme of aging and death are absolutely Dalí's. At the same time, he dealt with them from the perspective of the soft, the edible, the perishable and human; and of the hard, that which is inhuman and atemporal.

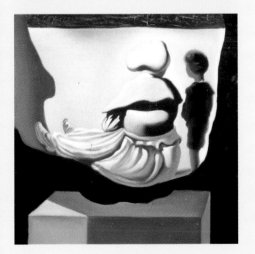

This face of the three ages is made up different fragments: two towns in the far distance of the bay form the eyes, while his nurse's back becomes the lips and the nose. The actor, the woman, alludes directly to the painter's own childhood, which recurred frequently when dealing with this theme.

The private autobiography of Salvador Dalí is the book where he transforms his childhood—and his life—into mythical territory. There, he tells of how he was the most coddled and pampered child that ever existed, and of his taste for the forbidden, which would plant the seed for all his adult obsessions.

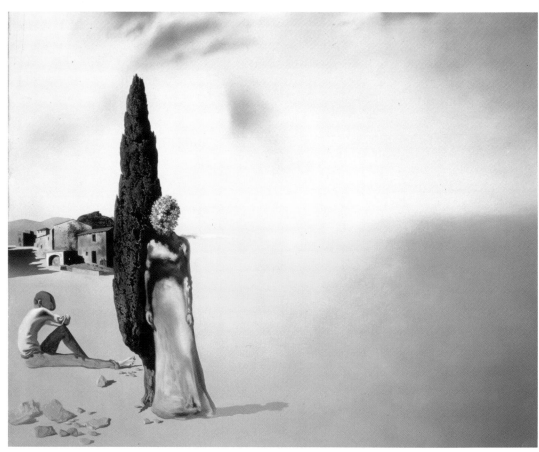

Necrophilic Spring
1940. Oil on canvas (19.7 x 23.62 inches)

mountain. For Dalí, Gaudí was one more example of the Spanish genius, always authentic, visceral, unique when placed beside French good taste, which he considered one of the most boring and ill-fated artistic manifestations in history. When *An Andalusian Dog*, the film that Dalí made with Buñuel, premiered, the artist intended to deliver "a blow to the heart of the intellectual, elegant, and cultured Paris." And he did so: during one of the film's showings, a right-wing Catholic group erupted into the cinema, striking spectators and destroying the paintings on exhibit in the vestibule. Always accompanied by scandal, Dalí conquered Paris as a preamble to his conquest of the world.

From childhood, Gaudí showed himself to be a highly sensitive person, with an acute sense of reality far greater than that of his companions. Dalí, in his autobiographies, presents himself as an *enfant terrible* who experiences enormous pleasure in the face of everything that is prohibited, with a very marked hedonism

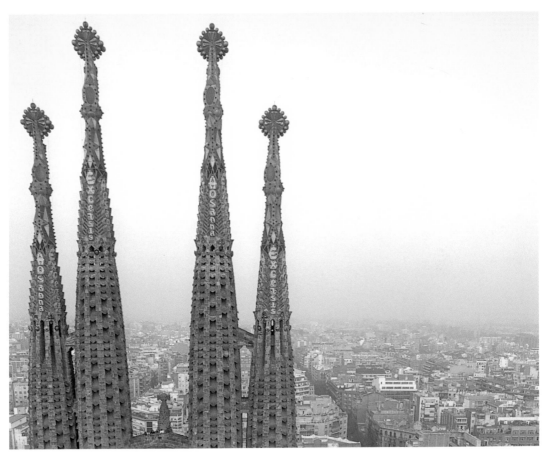

The temple of the Sagrada Família
1883-1926

and capable of an understanding of reality beyond that of his peers. It seems that from childhood both men developed an enormous capacity for introspection toward nature, this being a characteristic of their work: they worked in the terrain of the most profound, exploring depths no one else has reached.

This investigatory vision centered on the landscapes nearest to hand: Dalí always painted the Costa Brava landscape and the land around Figueres, giving them a magical status; Gaudí collect-

ed tiny wildflowers from the Sagrada Família site and asked the sculptors to copy them for the pinnacles of the apse as an homage to his venerated Nature. Gaudí and Dalí shared a common sensitivity, the same passion for reality and nature.

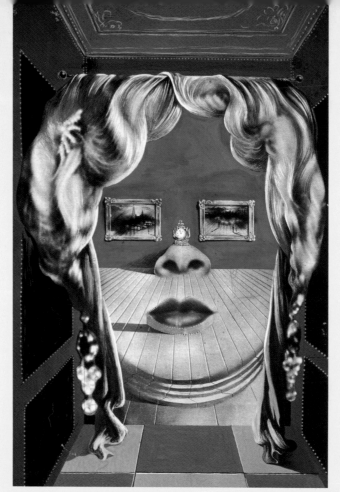

Face of Mae West Which May Be Used as an Apartment
Gouache on newspaper, 1934–1935

FURNITURE AND DESIGN

The search for detail

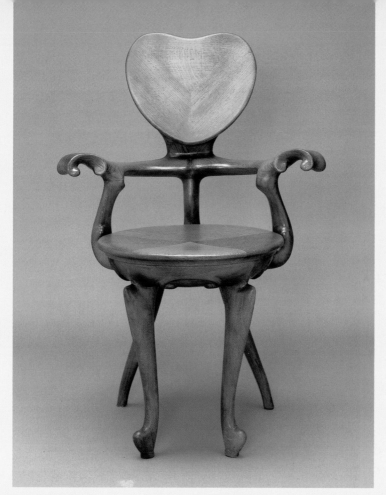

Calvet Chair, 1898-1900

Gaudí showed great attention to detail. He was capable of demolishing what took weeks to construct because he was not satisfied with the result (to the horror of the owners). A building's frame was to him on par with the smallest detail of a door or the most unassuming chimney on a roof. Dalí was also an untiring worker who carried out his concepts to include astonishing details, as well as being the only person among the Surrealists to develop a solid theoretical corpus. Dalí was interested in everything, and thus worked as an interior decorator as well as an architect, constructing pavilions or designing furniture.

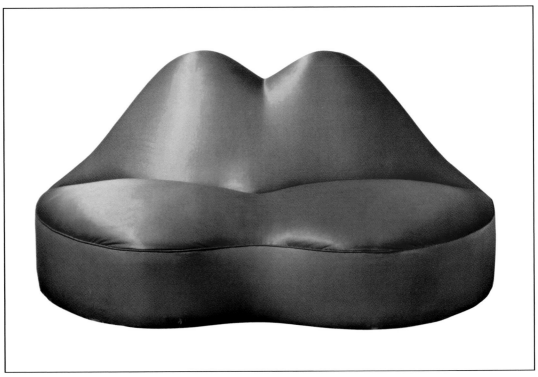

Mae West Lips Sofa
Upholstery on a wood frame, 1936–1937

With regard to his architectural career, Gaudí came consider himself a rare bird in the history of art, though his work as furniture designer is more in keeping with the modernist movement in Catalonia. Even so, he included details that reveal his strong personality.

Gaudí considered himself a bad draftsman and, highly conscious of his lack of skill with the pencil, attended adult education classes at the Acadèmia de Sant Lluc, where a very young Joan Miró, who also had drawing issues, secretly admired him.

Perhaps this shortcoming led the architect to prefer crafting models of his projects rather than drawing them on paper. In any case, in the commission for the prestigious tiled Escofet house in Barcelona, while the other Catalan architects and decorators presented their projects on paper, Gaudí went beyond the pre-established custom again and created a wax mold. From this he made the mold

for a tile of a single color, hexagonal in shape and in relief. With this solution, different designs for the blueprint were unnecessary since with the repetition of the same tile —one in the center and six arranged around it— the drawing on marine motifs was complete. This solution allowed all kinds of surfaces to be covered. It was also much more lasting and economical than those of his contemporaries and, although the piece has only one color, blue-green, it maintained personality in the chiaroscuro relief. The project, planned in principle for the children's room in the Casa Milà, today also covers the Passeig de Gràcia in Barcelona, one of the city's homages to the talented architect.

One of the unmistakable hallmarks of Gaudiesque furniture is its function and comfort. These are furnishings where we note the artist's total control of the material. He modeled to his own liking in wood or in iron, not infrequently in a single

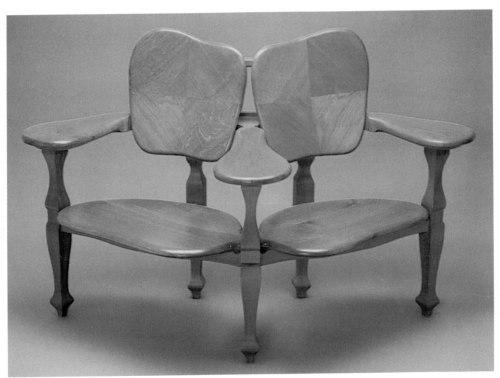

Batlló Bench, 1904–1906

piece. But what may strike us today as surprising for that time is the search for comfort. Gaudí is a designer who pre–dates ergonomics by more than fifty years, as may be seen in the most striking piece of "furniture": the comfortable, functional, and unrepeatable bench in Park Güell. It is said to have been made from the measurements of one of the laborers who was working on the project!

Dalí's main quality as a designer was not exactly comfort. He himself observed, in regard to the Mae West Lips Sofa, that lips need not be comfortable. Nor did he ever necessarily seek the functional: equally well known are his remarks to the effect that art is that which serves for nothing and that he himself was a fanatic about everything that had no clear use, though one should take into account that his statements at times seek to provoke more than to express his true thoughts.

In the midst of the remodeling of Paris at the beginning of the 1930s, and

before the fall in prestige of Art Nouveau, Dalí was one of the few ready to defend it and speak against the destruction of Hector Guimard's metro entrances. He even asked Brassaï to photograph them to illustrate his article *De la belleza terrorífica y comestible de la arquitectura del modern style* (On the terrible and edible beauty of Art Nouveau architecture), which would also be accompanied by photographs of Gaudí pieces by Man Ray. Dalí said that thanks to this article Parisians realized the value of the metro entrances, which today make up part of the city's image, along with the Eiffel Tower and the Latin Quarter. Perhaps the function of objects for Dalí is not so much physical as visual: his objects strike the imagination, but not so palpably.

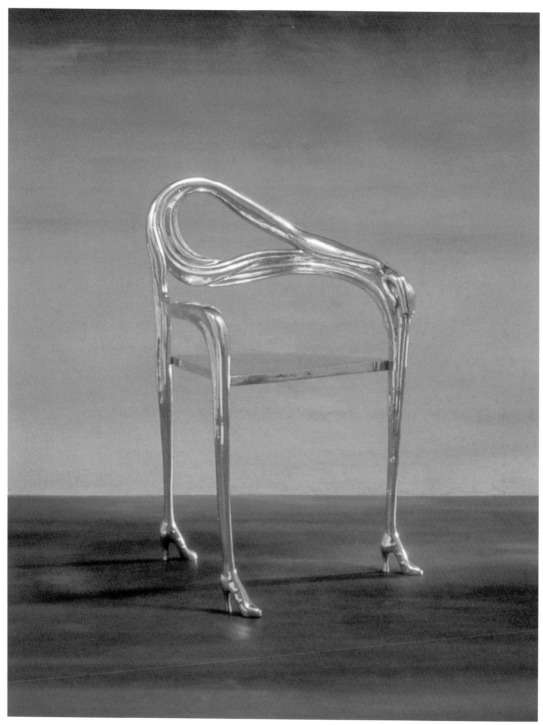

Leda Chair

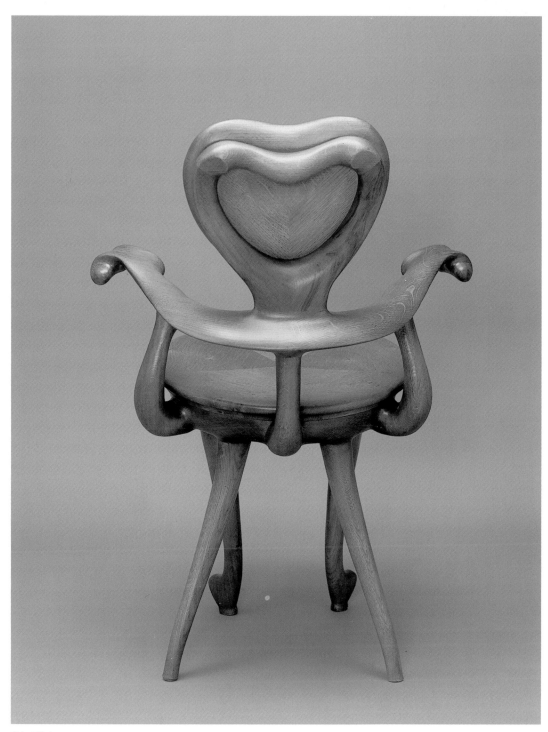

Calvet Chair

SALVADOR DALÍ

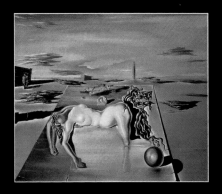

SALVADOR DALÍ 1904–1989

From a very early age, Salvador Dalí showed great skill at painting. At age ten, he discovered Impressionism, and by age fifteen painting would be his only interest. At this time, in the magazine of the school he attended in Figueres, he wrote about painting's great masters: Michelangelo, Velázquez and El Greco. This adoration for the great painters he would never abandon and was already beginning to be reflected in his critical acuity and his great sensitivity for painting. In his native Figueres, he began to build his reputation as an eccentric, always behaving audaciously before his teachers and among his fellow students. This eccentricity makes up part of the Dalí myth, something which he himself would take care to cultivate and add to over the years. In his autobiography, written in the 1940s, he tells an endless number of anecdotes from this time, and presents a child distanced from his peers, cruel and capable of dominating all situations, passing himself off as crazy. He was entranced by the idea of having everyone exclaim "That Salvador is mad!"

In 1921, Dalí was accepted at the School of Fine Arts in Madrid. Here, he would display the same behavior —he discredited the teachers, doing the opposite of what they asked, and astonished all the students with an ongoing display of extravagances, such as wearing varnish in his hair instead of hair cream— leaving his hair as hard as metal and obliging him to wash his hair with turpentine. But aside from this cultivation of a personage characterized by eccentricity, Dalí worked untiringly. Disregarding his teachers' instructions didn't mean not studying; he read and subscribed to the most avant-garde reviews. And above all he painted everything; he painted like a man possessed, already setting his sights toward Paris, the cradle of all vanguards. Dalí's friendship with Luis Buñuel and Federico García Lorca dates from this time—with the latter, he would spend several summers in Cadaqués at the family home, an idyllic place for three friends.

In 1925, Dalí had his first one-man show at the Sala Dalmau in Barcelona, the most avant-garde gallery in the city, where Picasso and Miró had already shown. This would help the young Dalí to convince his father to let him go to Paris, a trip that would be realized the following year, before his expulsion from the Madrid academy (for refusing to answer the questions on an exam because he considered himself more knowledgeable than his teachers). In Paris, a timorous Dalí met Picasso, whom he adored. Years later, he would admit that the meeting for him was like being before God.

Dalí realized that gaining fame meant making a name in the French capital, as Miró and Picasso had done, because the city was the center of the art world. After military service and several years among the Barcelona avant-garde, Dalí prepared himself for an "assault" on the heart of Paris. In 1929, he worked with Buñuel on the film *Un chien andalou* (*An Andalusian Dog*), a work that divided Parisian society. While an ultra-Catholic group attacked the spectators at a showing of the film and destroyed the Surrealist pictures in the hall, half of Paris was madly applauding the two young Spaniards. Dalí met the writer Tristan Tzara, the poet Paul Éluard, and the Surrealist group. That summer, he spent another of his idyllic vacations in Cadaqués in the company of his new friends. It was here his relationship with Gala, Éluard's wife, began.

This photograph, taken before Dalí and Gala began their relationship, is a superimposed aleatory image of two different negatives. Dalí interpreted this picture as a sign of the destiny at work in the life-long bond the two would share.
Helena Ivanovna Diakonova –Gala– was born in Kazan (Russia) in 1894, a date discovered only after her death. She was possessed of a strong character that would make her not only Dalí's muse but, years earlier, when she was still married to the poet Paul Éluard, the inspiration of various writers and artists, among them Thomas Mann, who would base the protagonist in *The Magic Mountain* on her.

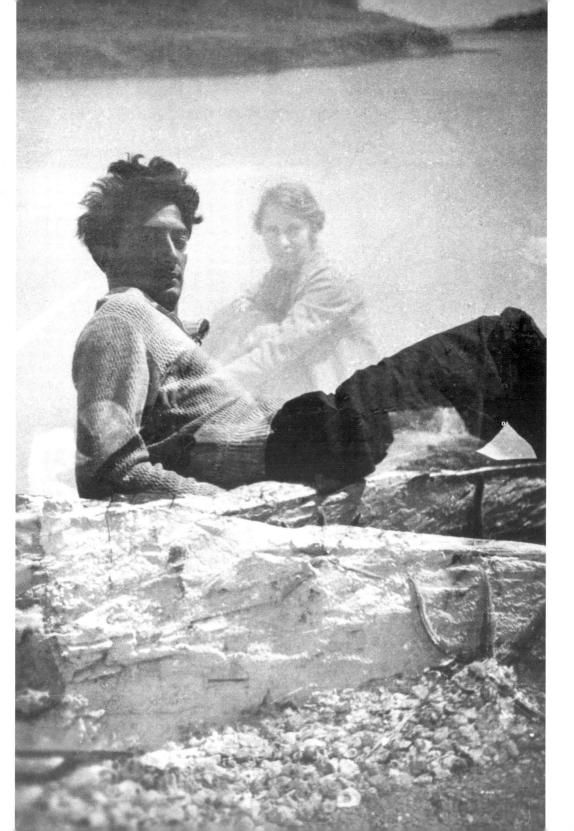

The painter's father, the notary public Salvador Dalí i Cusí, would not accept his son's relationship with a married woman. Considering that the painter had shown a grave lack of respect for his mother's memory –he learned that Dalí had titled one of his Parisian paintings *At Times I Spit in Pleasure on My Mother's Portrait*– Dalí's father disinherited him and expelled him from his house.

But the painter, who until that time had never worried about his up, refused to ask his father's forgiveness. He financed his relationship with Gala by selling his first pieces in France and thus gaining financial independence. Little by little, he would forge a reputation in Paris, given shelter by André Breton. Salvador Dalí's paranoic-critical method would soon revolutionize Surrealism, and both his pictorial talent and his intellectual acuity (and his peculiar mise-en-scène) would catapult him to fame in a few short years. In 1932, he exhibed in the United States for the first time while his relationship with the Surrealists deteriorated. Breton expeled him from the group in 1939, for Dalí's confusing declarations in regard to Hitler and for not belonging to the Communist Party (years later, Dalí would define himself as neither fascist nor communist but Dalinist).

Accompanied by Gala, the painter fled the European wars and lived for eight years in the United States (1940–1948), where he aroused great admiration. He collaborated with, among others, Alfred Hitchcock, the Marx Brothers, and Walt Disney. On his return to Europe, his fame was more than assured. In 1951, he published his mystic manifesto and began his nuclear phase, adding to his painting the most novel theories of physics and taking great pains in depicting exterior reality. If, in his superrealist phase, he wished to reach the deepest level of being, he now sought to draw the relationship between objects, the mysterious physical force that joins molecules; nothing more and nothing less than the forces of attraction and repulsion of the atoms.

In succeeding years he lived in Port Lligat, Catalonian, but still managed but to travel all over the world. His fame would precede him in all his journeys; both the fame of the eccentric madman and that of the painter of genius, creating admirers and detractors everywhere, but leaving no one indifferent.

In addition to the fame that his personage gained, his work would inspire increasing interest on the part of the critics, which would mean retrospective exhibitions in museums the world over. In the face of this profusion of shows, in the 1970s Dalí decided to sponsor a temple dedicated to his ego, simultaneously promoting the image of his native city. He would find no better place for the Gala-Salvador Dalí Museum than the center of the Ampurdán region, surrounded by the landscapes he so loved.

Gala died in 1982. Dalí ceased to paint the following year. He died on January 23rd, 1989 after a life dedicated to seeking fame and renown for his intellect and, above all, a life dedicated to painting, which he loved and venerated.

The Dream
1937. Oil on canvas (20.1 x 30.7 inches)

The Great Masturbator
1929. Oil on canvas (43.3 x 59 nches)

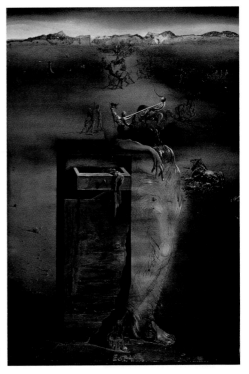

Spain
1938. Oil on canvas

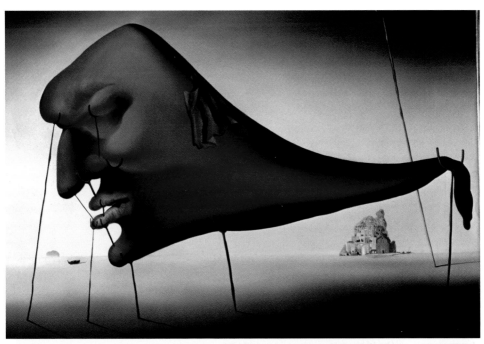

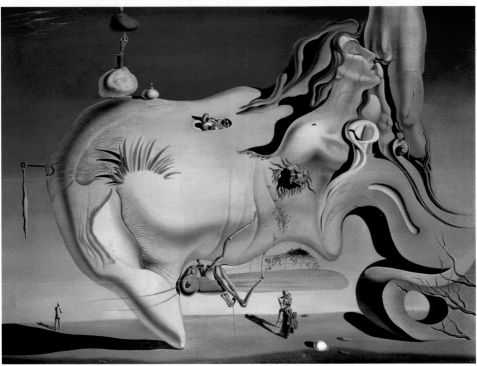

CUBIST SELF-PORTRAIT

1923. Gouache and collage on cardboard (41.3 x 29.21 cm)

At the young age of nineteen, Salvador Dalí was totally immersed in the avant-garde movement. He subscribed to all the Parisian journals he could and his persona seemed modeled on the modern ideals he read in their pages. His rebellious attitude at the Madrid School of Fine Arts had already cost him a year's expulsion. His apparent political radicalism had translated into a month's prison sentence in his native Figueres. Far from letting himself be worried, Dalí was overjoyed at all of these incidents since, for him, there was no greater sign of modernity than the failure of his peers to understand him, including his father. But the latter still consented to his son's caprices since, though he failed to understand him, he could see the hours he spent before his easel.

In Dalí's 1923 *Cubist Self-Portrait* features some of the favorite collage elements of Picasso and Braque, a folded newspaper and a pack of cigarettes. Also, the decomposition of the image follows the basic postulates of Cubism. Although the work doesn't reach the essence of the purest Cubism, it is evident that it is playing with cubism's possibilities. The range of blues and grays perfectly combines with the add-on elements while the central composition is very carefully worked out.

This piece must be understood in its context, in the formative stage of the young painter. Dalí wished to be vanguardist. He did nothing but work, without paying the slightest heed to his teachers and while looking to Paris, copying and studying everything that happened in the French capital.

Photographic montage by Dalí for the frontis–piece of his book *El amor y la memoria* (*Love and Memory*). The original photograph of Dalí with his head shaved was made by Buñuel in Cadaqués, years before he met Gala. But Dalí's relationship with Gala was so close that he said he had known her all of his life, since birth, as the relationship was predestined.

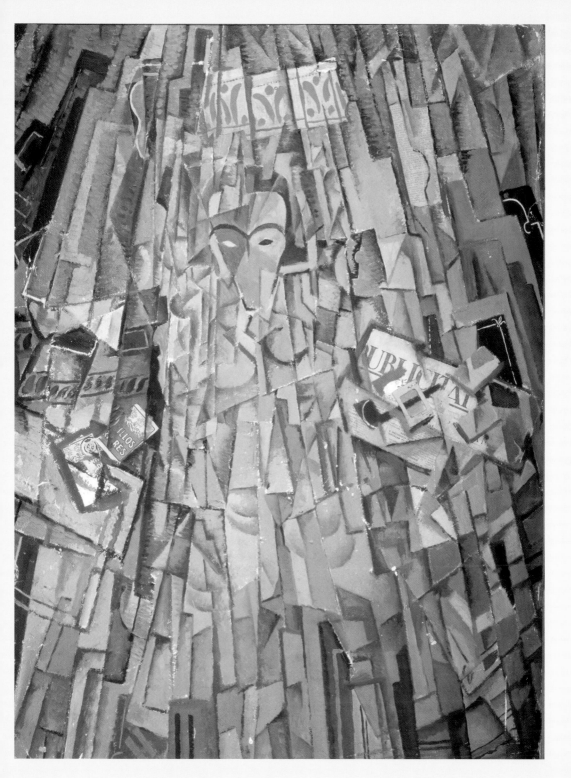

THE CHEMIST FROM FIGUERES WHO IS NOT LOOKING FOR ANYTHING AT ALL

1936. Oil on wooden panel (11.81 x 20.47 cm)

In "The Chemist from Figures who is not Looking for Anything at All", the plain vibrates in the Mediterranean light, more like a desolate desert than a place where people live. The wideness of the landscape, in part achieved by a horizon line placed very low on the canvas —disproportionately emphasizing the empty sky— works like Chirico's pictures, where something seems kept from us, as if behind the rocks or in the mid-plain building, action we cannot see but must be taking place. Chirico's landscapes are always urban, but Dalí evidently learned this disquieting mise-en-scène from the Italian (Greek-born) master he and the other Surrealists admired.

The pharmacist is a personage that was repeated in other works in this phase, almost always in the same pose, well dressed and respectable-looking; a portrayal of the well-off bourgeois. He always appears in absurd situations, as here, where he is looking for absolutely nothing, a critique of the bourgeoisie who base their lives on a series of social conventions empty of meaning or vitality. Dalí always attacked the bourgeoisie, considering it the social class with the most cowardly and ill-fated taste in history.

Necrophilic Spring
1940. Oil on canvas (19.68 x 23.62 cm)

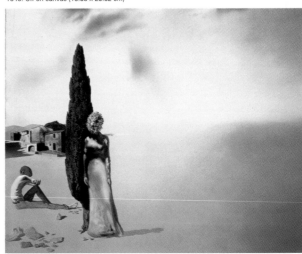

This painting shows the Ampurdán plain, which here takes on an extremely mysterious and ethereal aura. Every element in the piece is extreme, with most of the surface of the canvas left empty. The empty plain gives more attention to the two figures portrayed, emphasizing their strangeness.

ATAVISM OF TWILIGHT

1933-1934. Oil on canvas (5.51 x 18 inches)

The *Angelus* is a painting by Jean-François Millet that obsessed Dalí from the moment he first saw it in Paris (although he had grown up with a reproduction in his family's house). The scene portrays two peasants praying in a field before the sun comes up and their work begins. They are beside a small wheelbarrow. His obsession reached such a point that Dalí actually asked the technicians in the Louvre to study the painting, certain that it concealed something because its light did not correspond to the time when the angelus is prayed to. After X-raying the piece, they found that underneath the wheelbarrow was an image that appeared to be a small coffin. In light of this discovery , the two very sad figures in the picture acquired their real significance; they were not praying before beginning work, but because they had just buried a child.

Dalí's refinement and sensitivity made him capable of perceiving this type of subtlety and, contradicting all the historians who had studied the *Angelus*, he launched a new hypothesis that would later be confirmed through detailed study.

The well-intentioned theme and the strong Christian *ora et labora* (pray and work) moral of the *Angelus* gets transformed under Dalí's eye into a metaphor for the tensions that exist between men and women submitted to the tyranny of matrimony. Within the sensitive and biting imagery, this bucolic and innocent scene transforms itself into the power struggle between the sexes, the female figure a religious mantis about to spring on the male figure, now a cadaver. For Dalí, this is the real meaning buried beneath the work. This, and not the Christian theme, is why it was so popular: it unconsciously portrays the most profound and uncontainable human passions.

Meditation on the Harp
1932–1934. Oil on canvas (26.38 x 18.5 inches)

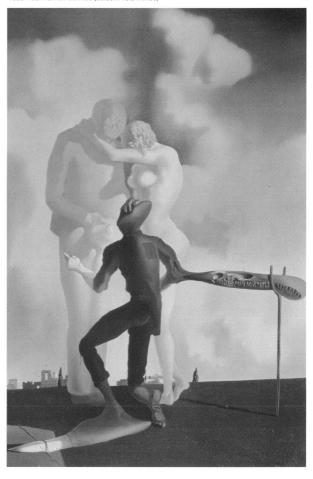

In this painting the two figures from Millet's *Angelus* embrace one another as a third figure kneels before them in a position rife with sexual connotations – its head level with the couple's genitals and its arm penetrating the man´s flesh. A protrusion in the form of a skull juts out from the elbow of this figure, condensing in this image the two vital instincts *eros* and *thanatos* (life and death) elucidated by Sigmund Freud, whose work greatly interested Dalí.

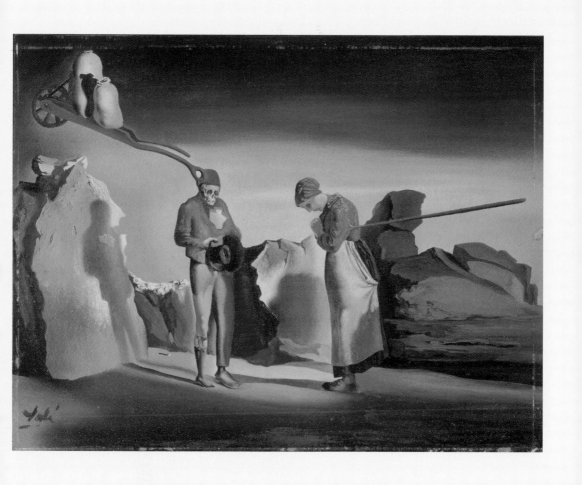

THE ENIGMA OF WILLIAM TELL

1933. Oil on canvas (79.33 x 136.22 inches)

The story of William Tell recounts the famous legend of the swiss hero forced to shoot an apple off his son's head. Dalí's interpretation of this story is of the father keeping his son from developing himself as he would like. In the series of paintings he dedicated to this tale, of those that show the Swiss bowman in the guise of a decrepit and incestuous old man, only one managed to scandalize the Surrealists themselves. Breton and his followers were stupefied to see that Dalí had painted the face of Lenin on one of the figures of Tell. They interpreted this as equating the Communist leader with a despotic "father," incestuous and cannibalistic. The portrait and Dalí's rather disturbing statements about Hitler –he admitted that he experienced a "Wagnerian and pleasurable ecstasy" at the sight of the dictator's body confined in the leather harnesses of his uniform– were the ideal excuse for André Breton to expel the Spaniard from the group.

William Tell represents Dalí's father, who opposes his relationship with Gala. At the same time, the piece of flesh he holds in his arms is the son, on the point of being devoured. Beside the monster's foot is a small nut, with an almost invisible Gala (due to the size) on the point of being squashed by the giant. These were, of course, the years of the ruptured relationship between the notary and the painter. Dalí was making progress alone, triumphing without the aid of his father. It took ten years for father and son to write to each other again. The trauma of the Spanish Civil War greatly upset Dalí's sister and profoundly affected both father and son, although the latter would never publicly say so. But he did admit that the time of the William Tell syndrome had come to an end, reconciling him with his family.

The Enigma of Desire–My Mother, My Mother, My Mother
1926. Oil on canvas (43.3 x 59.3 inches)

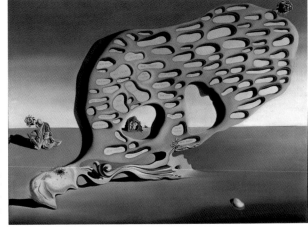

In *The Enigma of Desire* Dalí immerses himself in the Oedipal conflict described by Freud. The figure of the "great masturbator," which was, to a certain extent, a self-portrait of Dalí, extends from an abstract form full of openings on which the words "ma mère" (my mother) are written several times. With this image Dalí, under the influence of Freud, examines the most profound and hidden human instincts.

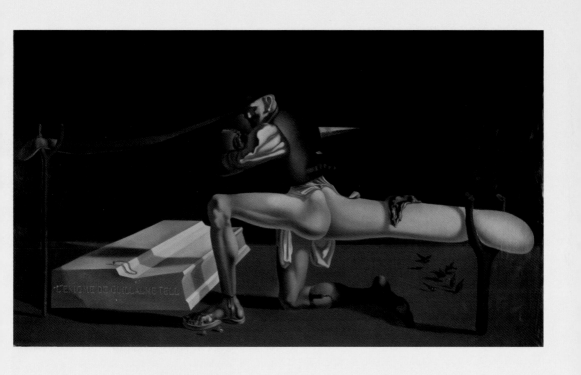

ANTHROPOMORPHIC CABINET

1936. Oil on canvas (10 x 17.4 inches)

Dalí sought to create paradoxes before which the viewer would feel disconcerted enough to suspend reason. Asking oneself "what something is" may start the free association of images and ideas. From this suspension of reason viewers need to reinterpret "what they are seeing". Hence, faced with the anthropomorphic cabinet, knowing that it isn't a cabinet or a person, the viewer has to decide what it means or signifies. But the exercise is not gratuitous; Dalí always worked out of a vast cultural and symbolic background: the figure comes from the baroque painter Barcelli's "caprices." It transforms the person-cabinet of the Italian into a metaphor for Freudian psychoanalysis. Here, patients empty themselves of all of their traumas and unconscious desires, without which they lose their humanity. These interpretive keys help in understanding the picture, but without knowing them the work is still powerful and captivating.

"The human body today is full of secret drawers that only psychoanalysis can open." This statement of Dalí's shows that when he joined the surrealist group in 1929 he was not doing so as a provincial bumpkin coming to the capital. Dalí had a profound familiarity with the Viennese psychoanalyst's complete works that began in 1922 with his interest in the dream world . And he was never a passive member but quite the opposite; a short time after arriving in the capital, he earned the nickname "the thinking machine" because of his way with words and the acuity of his arguments. It is hardly strange that he was the only Surrealist to impress Freud or Lacan, or that Jean Epstein should write a short text praising his intelligence. As Agustín Sánchez Vidal observed, "Dalí was not only a painter, he was an intellectual adventure."

Venus de Milo with Drawers

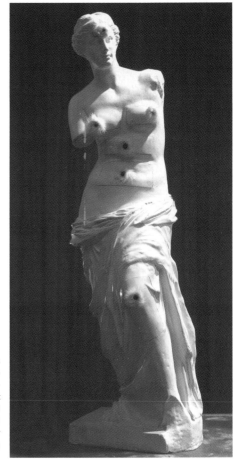

This piece was executed with the help of Dalí's friend Marcel Duchamp. It is not strange that these two artists got along, since they shared the conviction that the ideas in their work are more important than the form. The friendship between Duchamp and Dalí did not end with this sculpture; Dalí painted Duchamp on more than one occasion, and the latter spent a good deal of time at his friend's side during summers in Cadaqués.

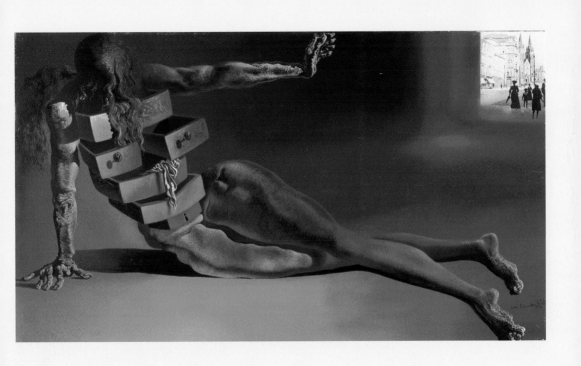

THE METAMORPHOSIS OF NARCISSUS

1937. Oil on canvas (20 x 16.9 inches)

This work, though painted when Surrealism was at its peak, shows elements of Dalí's later stages, when the artist's interest centered on classical themes. Here, the myth of Narcissus serves to create one of Dalí's best–known double images, giving rise to the feeling that the mirroring encloses an indecipherable mystery. However, it is not that anxiety-ridden and in fact is an example of the delicate touch of which Dalí was capable. The languid body of Narcissus remains inert, like a polished statue, and is distinguished from the rest of the piece by the diffuse light covering him. Viewing the image, we cannot see the beauty of the face in the reflecting lake. What we can see is the birth of a flower from an egg, a symbol of renovation from the time of the Renaissance. It is in no way surprising that Dalí should take such great pains over the subject of Narcissus. Egoism is one of the cornerstones of his existence and Narcissus is a figure not unrelated to the artist's own adolescence when, on hot summer days, he was capable of observing himself for hours before the mirror. Of all the interpretations of this canvas, could the most extensive be that of reading it as a metaphor of physical beauty?.

Invisible Sleeping, Woman, Horse, Lion
1930. Oil on canvas (19.7 x 23.6 inches)

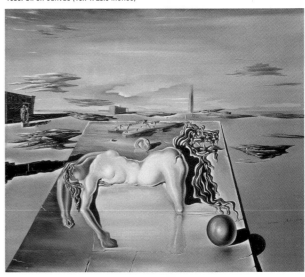

The first double image painted by Dalí appears in *The Invisible Man* (1929). After that work, he continued to study, creating optical games that combine more than one figure. His interest is not so much in the illusion but in the feelings his paintings provoke. The lion, for Dalí, is a sign of desire: here, he is again studying erotic human drives.

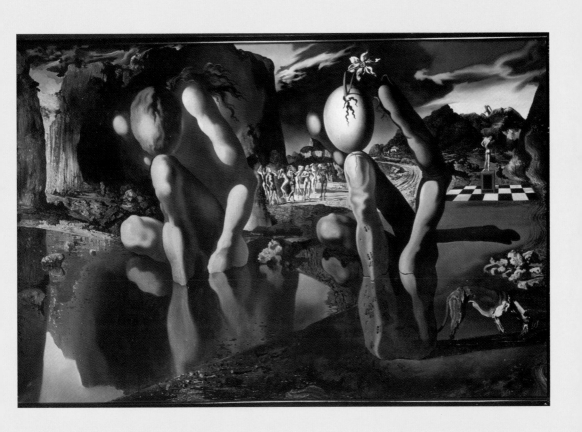

Soft Self-Portrait with Fried Bacon

1941. Oil on canvas (24.13 x 20 cm)

This self-portrait is one of Dalí's most popular images and contains elements already recognizable from the Dalí mythos (crutches, softness). Created in 1941, its pictorial capacity is superlative. The piece of bacon on the pedestal is of a realism comparable to the best Spanish or Dutch baroque still lifes. The facility with which the face reflects a subtle play of light and gradations of a single color show the mastery of its execution. But this is a unique image in the painter's career because the figure's grimace, a smiling one, gives him an amiable air that is missing in Dalí's other super-realistic works. It is an easily recognizable piece, apparently without ghastly occult meanings, which brings it close to the Pop Art forms that would triumph in a few years.

It is also an ode to fried bacon and North American gastronomy. But beyond this, and anticipating, as mentioned, the Pop movement, it portrays the culture of the United States, where everything is easy, open, and readable. This portrait of Dalí shows us not the deep Freudian research of European Surrealism but only the surface appearance of the face. The essence of North American culture is precisely this exterior, this appearance that a decade later Warhol would so well depict.

Aphrodisiac Dinner Jacket
1936 (destroyed)

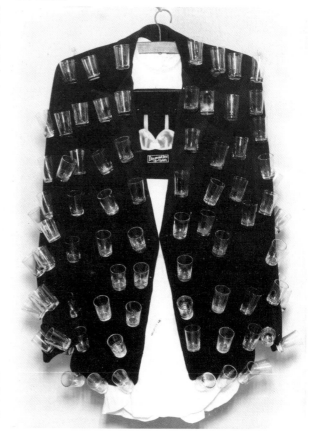

Dalí was quite proud to have made this piece, since he considered it a forerunner of Pop Art. Although there are obvious differences between Dalí and the Pop Artists, they have some interests in common, such as silk-screening objects or the use of images of objects that have become household words.

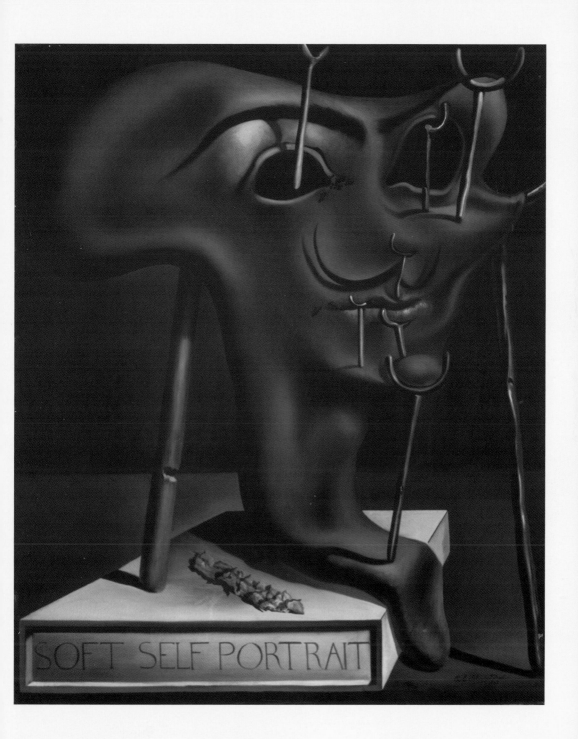

SOFT SELF PORTRAIT

THE ENDLESS ENIGMA

1938. Oil on canvas (45 x 56.7 inches)

Intentional distortion of images is, or use of multiple images, one feature that appeared in the baroque period as plays or studies in perspective. In them, the spectator can only see the image if they know how to look at the painting, whether through a mirror or at a determined distance or in some other way. Dalí's double images use this trompel'oeil world but seek an intellectual complexity that allows endless interpretations.

In *The Endless Enigma*, we see, without great effort, 1) a Costa Brava landscape with a woman and a boat and a man reclining, 2) a greyhound, 3) a man reclining, 4) the face of a "large cretinous cyclops" (a portrait of Federico García Lorca), stet 5 a still life. Depending on the degree of "crirtical paranoia," a method used by Dalí to view the world around him, other recognizable images can appear: bodies, faces, a mythological animal. The work is perhaps the most replete example of these endless associations. But it appears that all of the elements are in some way related to Lorca, assassinated several years earlier. This is certain only if the Granada poet was convinced that the "Andalusian dog" was himself and only if the greyhound that appears in the piece refers to him. But even today the extent of the influences between Lorca, Buñuel, and Dalí is not known. What can be certain is that, in spite of the events separating them, the three friends were vital to each other, and the death of the poet profoundly affected the painter, although he never admitted to this.

Apparition of a Face and Fruit Dish on a Beach
1938. Oil on canvas (45 x 56.6 inches)

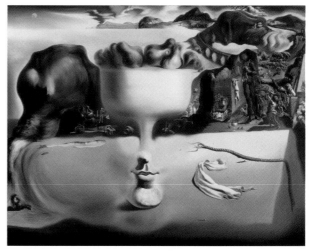

On the beach in this painting a mysterious portrait appears which many critics identify as that of the poet Federico García Lorca. From the time that Dalí went to Paris, in 1929, his friendship with Lorca progressively deteriorated. Even so, at the end of his life, he remembered the poet with great warmth.

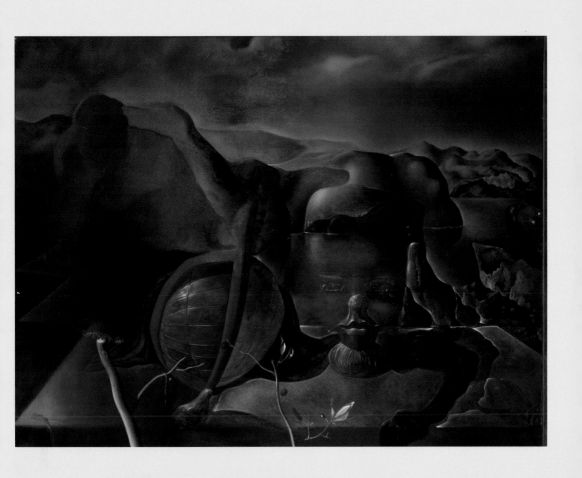

ATOMIC LEDA

1949. Oil on canvas (24 x 17.8 inches)

After the Second World War, Dalí's work took a new turn. He began to represent in his work the dynamic tension that attracts and repels objects, that is, the atomic forces that hold the particles of the atom together. It was a phase that does not negate the paranoic-critical free association in his earlier work, but rather it blends with it to continue investigating reality. From this interest, based on the new scientific discoveries —remembering that both Freud in the 1920s and Einstein in the 1950s are two undeniable intellectual reference points— this new phase also includes interests in Catholic mysticism and a return to classical motifs and forms.

The Greek myth of Leda tells how Zeus raped the nymph Leda disguised as a white swan. From the union, Castor and Polydeuces were born. During the Renaissance and the baroque, this was one of the few images where the female nude could be represented, and the only one where copulation could appear, although it involved a woman and a swan. Dalí is interested in the figure of Leda because of the challenge, present also in classical art, of representing this crude scence in a beautiful and serene way. However, the setting is also the conception of Castor and Polydeuces, the twin brothers destined to achieve mortality as children of Zeus, who placed them in the constellation Gemini. This idea of the death of a twin is one that obsessed Dalí throughout his life. He identified himself with his older brother with whom he shared the name Salvador and who died before the painter's birth. The Raphaelesque touches and the Renaissance proportions of this portrait of Gala as the nymph reflects the classical world but, paradoxically, shows the atomic tension. There is not a single object in contact with another, yet all are attracted to each other in this scene of the swan and Leda.

Galatea of the Spheres
1952. Oil on canvas (25.6 x 21.26 inches)

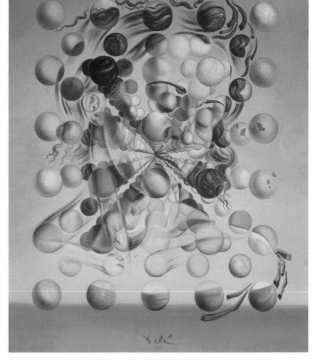

Both the classicism of the figures and the representation of the objects and their attractions are clear in all of the work done in this period. Although Dalí painted portraits of Gala throughout his life, those of the atomic phase are the ones that have become true Daliesque icons, especially in *Galatea of the Spheres*.

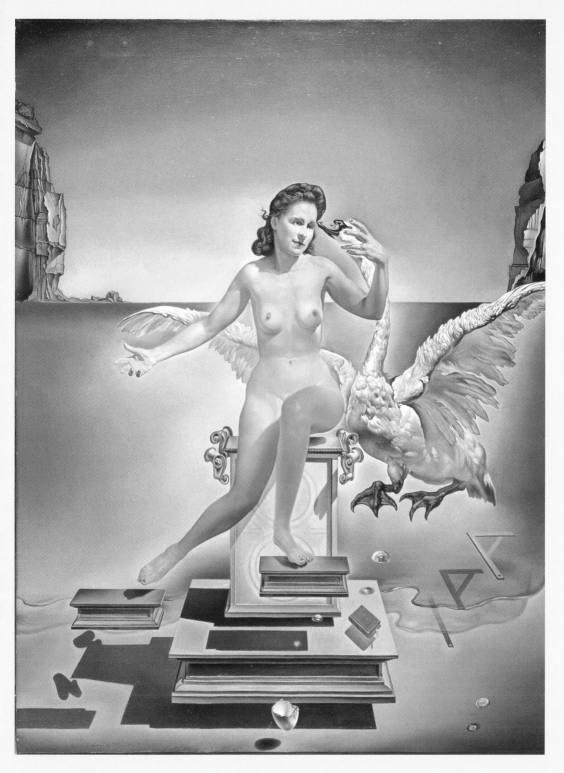

THE CHRIST OF SAINT JOHN OF THE CROSS

1951. Oil on canvas (80.7 x 45.7 inches)

This painting was inspired by a drawing of Christ, apparently done in a state of ecstasy by Saint John of the Cross (1542–1591). What is most surprising about the Spanish poet and mystic's drawing is the slanted perspective with which he represented Christ. It is reminiscent of the position the dying get into when presented with the cross to kiss. The Dalí composition recalls this image, as if the viewer were in fact in the bed. At the same time, as in other pieces from this phase, he renders homage to others painters he admires. The figure of Jesus Christ, with the head forward and seen against a deep black background, is inspired by the Christ of Diego Velázquez. Similarly, one of the fishermen comes from another canvas by the same painter, *The Surrender of Breda* , also known as *The Lances*. The representation of Christ in the painting before us, in any case, is absolutely serene. There is no pain of martyrdom portrayed; the focus is on the beauty of the poems of Saint John of the Cross. This is also the basis for the 1951 *Mystical Manifesto*, in which Dalí states that his painting seeks to go against the materialism reigning in contemporary painting, "not to represent man's heterogeneous individualities but the absolute unity of ecstasy."

Madona of Port Lligat
1950. Oil on canvas (56.7 x 37.8 inches)

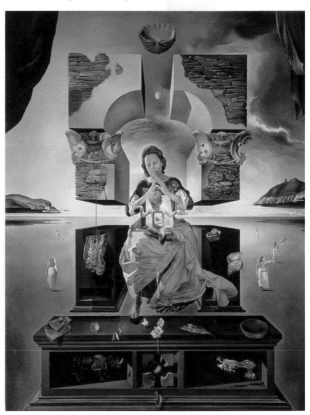

Dalí was not only interested in religion because of its strong infusion of mysticism. He was also attracted by its iconographic repertory, very rich in symbolism and recognizable the world over. His return to tradition as seen here is not a religious conversion but an embracing of religious representation in the classical themes contained in painting's by the great masters.

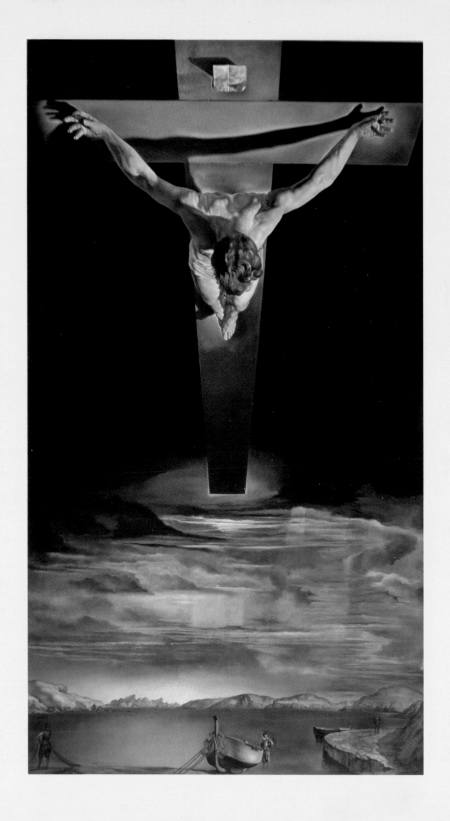